PAINTING WITH WATERCOLOR

Learn to Paint Stunning Watercolors in 10 Step-by-Step Exercises

HuesAndTones Media and Publishing

First edition

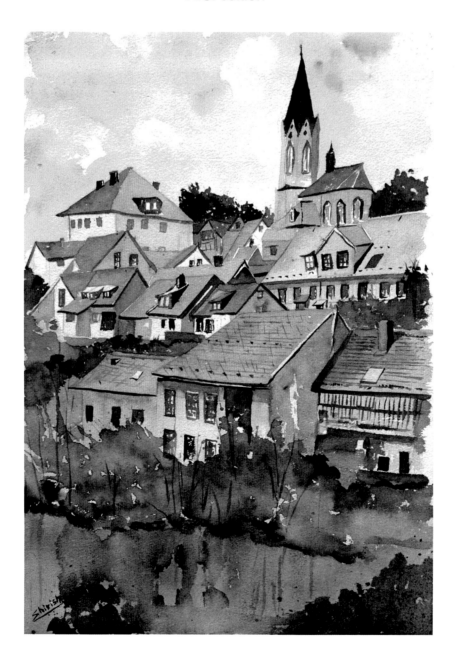

PAINTING WITH WATERCOLOR

Learn to Paint Stunning Watercolors in 10 Step-by-Step Exercises

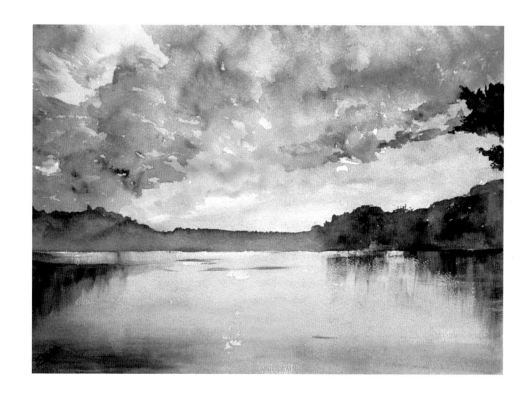

SHIRISH DESHPANDE

https://HuesAndTones.net

TABLE OF CONTENTS

INTRODUCTION

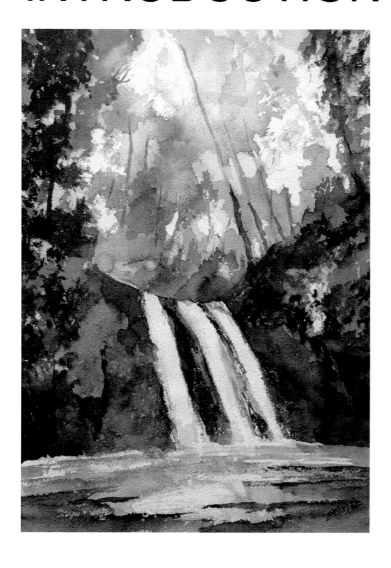

Watercolor is a magical, yet seemingly complex and unpredictable medium.

Due to the unpredictability and transparency of this medium, it sometimes behaves in a way an artist may not expect.

But this very unpredictability of watercolor can be used to great effect by someone who can enjoy and appreciate the possibilities that this medium brings.

The most common variety of watercolor that is used is 'transparent'. When one applies layers upon layers of watercolor, the base layer affects how the subsequent layers will appear. This can both be a boon and a bane. An expert watercolorist can use this property of watercolor to a great advantage, letting the colors mix and interact on paper.

Who is this book for?

Whether you are a novice in painting watercolor, or someone who is looking to enhance their skills as a watercolorist, this book is for you.

The goal of this book is to rid the reader(!) of the fear and uncertainty of watercolor painting.

Mistakes and Happy Accidents

Most wannabe artists never begin with watercolor painting because it's supposed to be an 'unforgiving' medium. They are afraid that a small mistake may ruin the whole painting.

This notion is not entirely false.

However, when you play with this medium for some time, you will learn its idiosyncrasies. That in turn will help you to enjoy the flow of painting a watercolor.

And eventually it will help you learn how to hide the mistakes that you do make.

Look, I am not saying that you will not make any mistakes. If your goal is to be flawless, let me tell you right away that you are in the wrong place!

Have a look at the serene seascape below. Do you spot a mistake somewhere?

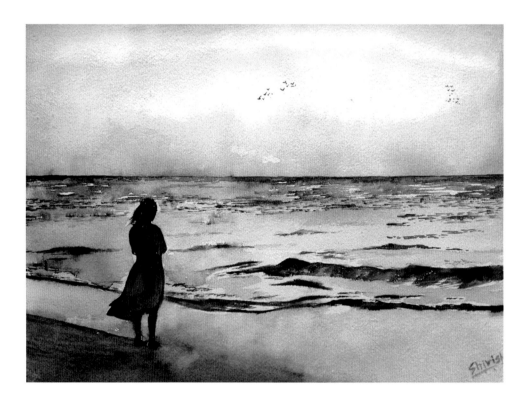

If you are a nitpicker like me, you may have found at least half a dozen mistakes by now.

But I am not talking about *those* mistakes.

I am talking about the one mistake that I have hidden away.

Do you see the two flocks of birds in the sky? They were not there in the original reference image.

But while painting this picture, I inadvertently dropped a small drop of dark paint where the forward flock is. This small drop, while tiny in size, was enough to distract anyone observing the bright sky in this picture.

So, I decided to convert the dark spot into a flock of birds.

When I painted the flock of birds, I thought it was too centered in the picture and needed a counterbalance somewhere. Thus, was born the second flock of birds at the top-right hand corner.

You can see from the example above that not all mistakes are irreversible. Something even better may emerge out of some of them.

Materials Used

I have used rough-textured 270GSM handmade paper for most of the illustrations in this book.

I use the following brushes for my artworks. I have accumulated these over the years. If you do not have so many brushes, you don't need to worry. Three to four synthetic brushes of various sizes are enough to begin with watercolor painting.

Think of having more high-quality brushes (or other materials) like having a better camera. The quality of photographs primarily depends on the photographer, not the camera. If a person is an expert photographer, he/she can shoot good photographs even with an average camera. But, sure, they can shoot much better photographs with a better-than-average camera.

It's the same way with brushes (or any other material). Focus on making your art better. Better materials will further enhance your art. But top-of-the-line materials are not a prerequisite for beginning painting.

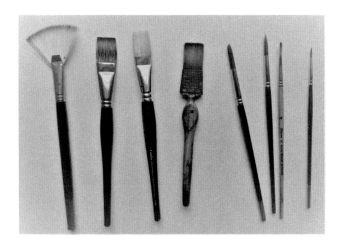

Fan brush (the first brush on the left-hand side)

This brush is useful for painting soft edges in a painting.

Flat brushes (first three brushes after the fan brush)

I use these brushes to paint big, sweeping strokes for large washes. They are also useful in painting straight lines for buildings etc.

Round Synthetic Brushes

These brushes are useful for painting all kinds of shapes. You may use different brush sizes depending on the area you want to paint.

Most paintings can be painted using 3-4 brushes.

I use synthetic brushes for all my paintings. Better quality and long-lasting brushes made from animal hair are also available in art supply stores. The best quality (and the most expensive) of these is a sable-hair brush.

I do simply fine without all these expensive fancy brushes and use only synthetic brushes.

And here they are (on the next page)!

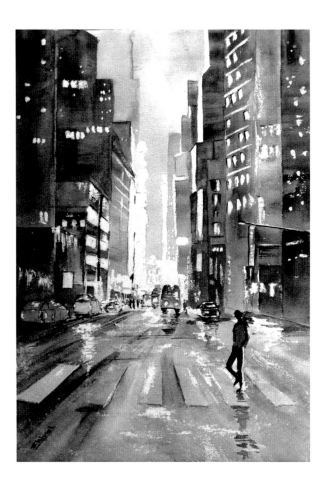

Note: I have used flat brushes extensively in the above painting.

Mop brushes and Chinese brushes

On the left-hand side in the photograph to the right, the four brushes shown are the mop brushes of various sizes. When these brushes are wet, we can manipulate their shapes to make their tips splayed or pointed. Thus, the same brush can be used to paint big strokes as well as fine strokes.

Brush sizes

The tip size of the brush you may want to use for your paintings will depend on the size of painting and the level of detail you want to paint.

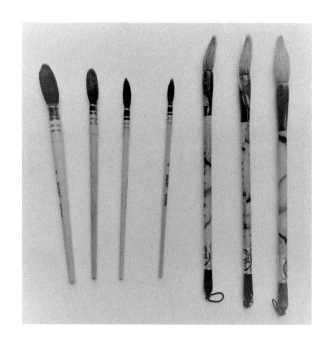

For A4 size paper (that's nearly, but not quite equal to 'legal' size in the US), a size 12-14 is enough for the base wash. I even use this brush for A3 sized paintings (most of the paintings in the 'Exercises' section are painted on A3 size paper).

My mop brushes are of sizes 0, 2, 4 and 8.

My Chinese brushes are of sizes 2, 4 and 8.

Apart from these brushes, I have collected some simple round brushes of various tip sizes (0, 4, 6, 11 etc) over the years.

An important note:

Even though this book is about watercolor painting, I have used some of my sketches/paintings in other mediums to explain some points. When explaining concepts like the importance of sketching or using dichotomies for interesting composition, it's sometimes easier to demonstrate the concept using linework.

Dictionary meaning of Dichotomy – *division into two mutually exclusive, opposed, or contradictory groups.*

Removing the color from an illustration also lets us focus better on the edges and contrast. So, let's understand and internalize the concepts first. We will learn to use these concepts with watercolor painting in the 'Shapes and Values' chapter.

Watercolor Tubes and Cakes

Personally, I prefer to use watercolor in tubes. It's easier to pour the paints into a palette/dish/bowl and mix them.

However, buying individual tubes may prove a little costly. If so, you may begin with buying a set of 12 or more tubes of assorted colors. These sets are more than sufficient for the beginners. Later on, you may start adding more paints to your arsenal as you progress.

Another option is to begin with color cakes (half-pan set). They are cheaper than tubes. They are also easier to carry around if you plan to paint outdoors.

Paper

The type of paper plays a vital role in watercolor painting.

Many types of paper are available at any good art supplies store. You may try several types before finding out the right fit for you. But here's a rough guide to what to look for when choosing a paper type.

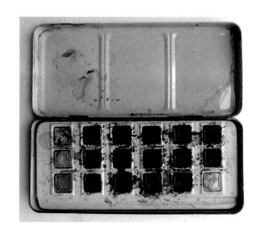

While selecting your paper, you need to consider the following things.
- Paper thickness
- Paper texture

Paper thickness is measured in GSM (Grams per Square Meter). Without going into details, just understand that the more GSM value is specified for a paper, the thicker it is.

Typical sketchbooks are available from 50 GSM all the way to upwards of 400 GSM thicknesses.

Smaller GSM papers (70-120 GSM) are ok for 'dry' work like sketching with pens/pencils. But these papers tend to buckle when using watercolor. Watercolor also tends to seep through thinner paper.

Bigger GSM value paper (upward of 250 GSM) is preferable for watercolor work.

For most of the illustrations in this book, I have used 270GSM paper.

Paper texture is also a vital component in determining the result.

Paper is manufactured using a hot-press or cold-press method.

Hot-pressed paper is smoother and has a more uniform texture than cold-pressed paper.

Even within hot and cold-pressed paper, you can find many levels of smoothness. You can also find rough handmade paper in many art material shops.

I mostly use a rough-textured handmade or cold-pressed paper. I prefer textured paper to smooth paper for watercolor. Using a textured paper allows me to create 'character' in the painting.

Other Material

The photograph on the right-hand side is of the color palette that I use (and I know it's a mess; but hear me out).

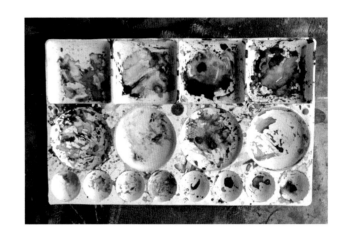

The smaller wells at the bottom can be used to pour paint out of the tubes, while the bigger wells in the middle and top rows may be used to mix various hues.

And one should not be as lazy as I am and wash their color mixing palette periodically!

You may even use a simple plastic dish for mixing the paints.

Or you may mix the paints directly on the paper. We will do such mixing during some of the exercises later in this book.

Transparent and Opaque Colors

Watercolor paintings are typically done using transparent washes. The transparency and rapid mixing ability of the watercolor is one of the unique strengths of watercolor.

But watercolor can also be used in an opaque fashion. The 'normal' watercolor can be used to create opaque layers by applying thick, undiluted paint over the paper. But opaque watercolor makes this process so much easier.

Opaque watercolor is available in two types:
- Poster color
- Gouache

Poster colors are thick and opaque, but not as colorfast as the gouache paints. This means that the poster colors may lose a little bit of their vibrancy over time. But since poster colors are so much cheaper than gouache, they are more widely used, particularly for painting large areas in a painting.

Poster colors are typically available in the form of bottles containing liquid/thick solid paint.

I sometimes use poster color (particularly poster white) in some cases to paint large areas. You will see some examples of this as we go along in this book.

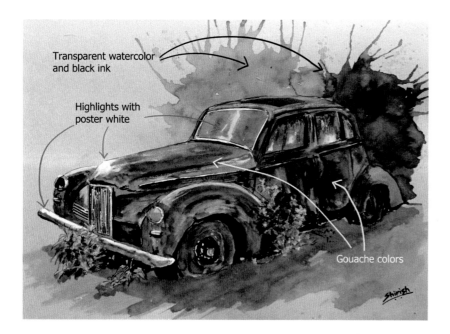

The sketch on the left-hand side uses both gouache and poster white.

The painting on the right-hand side uses gouache paints applied as thick paint for the pink wall around the arch.

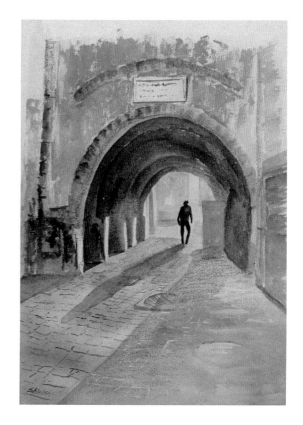

IMPORTANCE OF SKETCHING

Sketching is an important prerequisite for painting. Observing the world around you and learning to translate it to a sketch on paper is an important aspect of painting.

Sketching teaches you to 'see' the objects around you in a new way. Sketching makes you more aware of the world.

But most importantly, sketching allows you to be 'loose' with your work, and not get bogged down by details.

When we paint, we want it to be perfect. We also may have plenty of time on our hands. It sometimes forces us to play safe.

While sketching, particularly outdoors, we are mostly short on time. But we are free to experiment, to make mistakes and to enjoy the process.

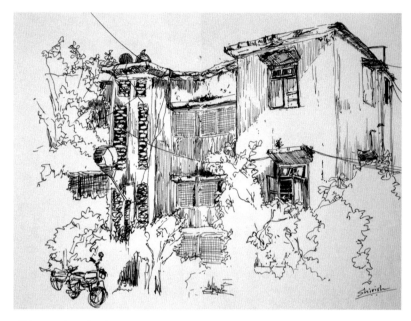

Sketch Info: I drew the above sketch during my lunchtime walk. It's a dilapidated building near my office.

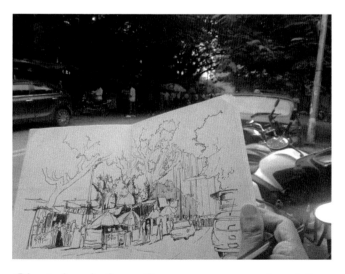

Sketch Info: Once more a lunchtime sketch, this time of the little tea and snack stalls opposite my office.

Once the sketching process is part of our being, we can carry over this looseness and spontaneity to our paintings too, and learn to enjoy the process.

It doesn't matter which medium you use for sketching. You may use pencil, ink, pen, watercolor, pastels, digital mediums, or any other medium you are comfortable with. The important task is to observe the world around you and sketch it.

Sketching also forces one's brain to think and plan about what to include and what to exclude in an artwork.

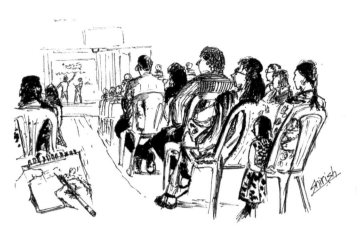

Not everything you see in your reference photograph or your view needs to be part of your painting. You will pick and choose only those elements which will make the most appropriate composition.

Depending on your mood and the time at hand, a sketch can be somewhat detailed (like the church sketch below)…

Sketch Info: *A quick sketch drawn while attending a stage show. Observe the body language of each spectator (and my drawing hand in the below left-hand corner!*

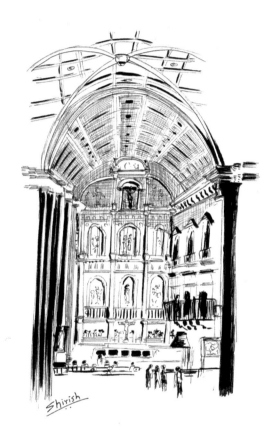

...or it may be very loose and even appear incomplete (like the house sketch below).

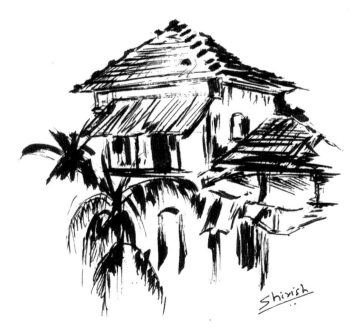

Sketch Info: *A detailed rendering of a massive church in Goa, India. It took me more than one hour to draw this one.*

Sketch Info: *A five-minute rendering of an old house in Goa, India.*

I will reiterate what I keep saying in every book of mine.

The only rule in art is that there are no rules!

So, whether your sketch is elaborate or loose does not matter. What matters is how it helps you become a better artist.

Make it a habit to sketch as often as you can. Not every sketch will become or lead to a painting. But every sketch will help you grow a bit as an artist.

Remember, sketching is akin to a singer practicing for him/herself. Painting is akin to a stage performance for an audience. The more consistent a singer is while practicing alone, the more he/she will be in the groove while performing on stage.

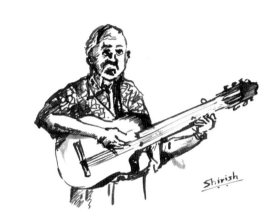

Enjoy a few more detailed sketches below:

Sketch Info: _A guitarist playing traditional Portuguese music in Goa, India._

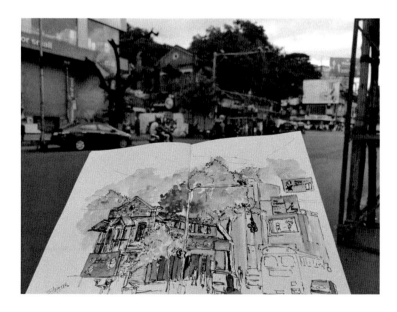

Sketch Info: _A sketch done on a quiet Sunday morning on an otherwise bustling street in Pune, India._

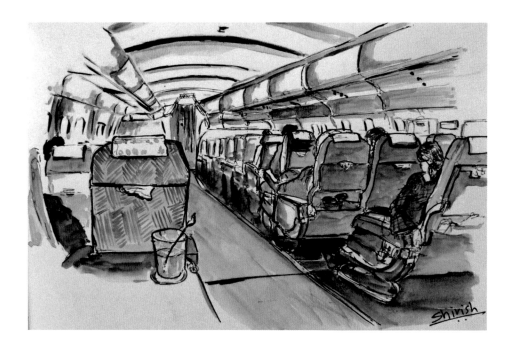

Sketch Info: *Passing time on a flight is always a nightmare for a person who has difficulty sleeping on a flight. What better way to pass the time than a nice little sketch? I painted this sketch on the flight back from Cambodia to India (You can read more about this adventure in my other book 'Pen, Ink and Watercolor Sketching 2 – Temples of Cambodia').*

https://huesandtones.net/books/piw2/

Plane interiors are perfect for practicing perspective sketches, and one can even make a few friends along the way! I will also mention here that I used a box of watercolor cakes for painting this sketch. It would be nearly impossible to paint this sketch using paint tubes in the economy class space!

SHAPES AND VALUES

In painting-speak, the word 'value' refers to the darkness or lightness of an area in a picture.

Understanding the values within a picture is extremely important while painting. It serves two purposes:

- Understanding values helps us better understand the broad shapes within a picture.
- Using the values correctly means making our paintings more understandable to the viewer and can add a certain 'pop' to the paintings.

I will explain both the above points (in plain language) in the next few pages.

Let's use the reference photograph below to understand the concepts of shapes and values.

If you begin directly drawing/painting this picture, you may find yourself entangled in the detail-trap in no time. Getting trapped in detail is a perfect recipe for frustration.

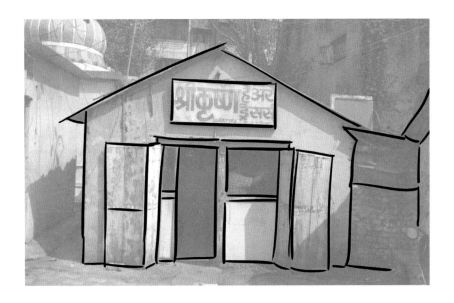

Instead, learn to look at the object through the lens of shapes.

You don't need to be perfect. Just mark the shapes using light pencil strokes. The following picture shows the rough shapes I came up with.

Note: *The thick black outline you see in this picture is drawn that way for your understanding only. When you draw the outline, make sure you use light pencil strokes which can be erased easily later if you need to.*

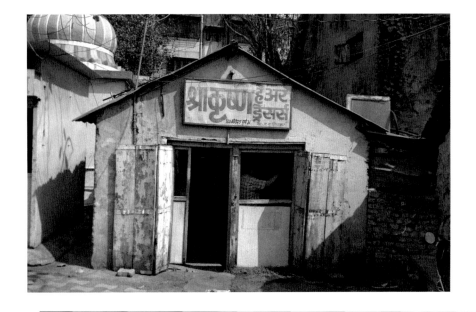

Now let's understand how to determine the values. First, let's convert the original reference photograph to monochrome.

Now squint your eyes and look at the monochrome photograph above. You may see the photograph somewhat like this.

You may notice that you have lost all details in the photograph and can see only black, white, and few shades of grey.

These black, white, and few shades of grey are nothing but the values. You can also notice that you can now more easily perceive the photograph as a collection of various shapes.

One important point to note: *In the paragraph above, you may have noticed that I said that the black shapes correspond to the 'darkest of the dark', not black.*

Why?

Because the darkest value in a painting may not necessarily be black.

There is no pure black in nature. Even if an object is painted pitch black, it still appears to have some color due to the light falling on it.

Our job as an artist is to understand values and shapes and use them to our advantage.

You may begin with a simple value sketch like the one above.

The number of intermediate (grey) shades depends on the source material (reference photograph or the scene as you are experiencing it). My experience is in most cases, 3 to 5 grey shades are enough to depict most scenes.

Following is the final painting based on the value sketch above:

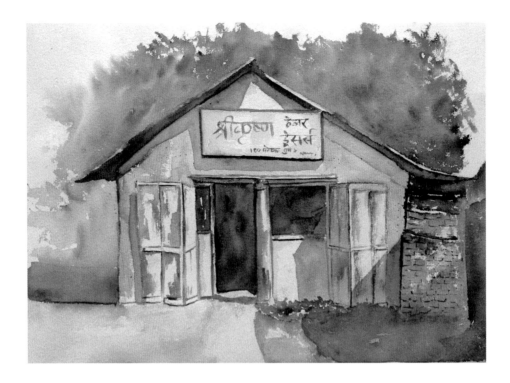

You may observe a few deviations from the value sketch. For example, I had not painted any values for the background foliage in the value sketch. However, I decided to include the foliage in the final painting to create a frame around the main subject.

Value sketches are meant to be a reference point for planning your painting. They're not meant to be followed without any thought.

COLORS

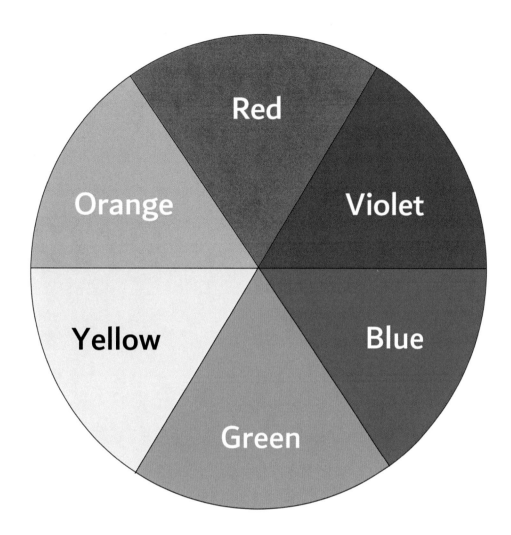

L et's understand some basics about colors.

This is a *color wheel*. It represents the primary colors (red, blue, and yellow) and the secondary colors derived by mixing the primary colors.

For example, green is obtained by mixing yellow and blue. Violet is obtained by mixing red and blue. Orange is obtained by mixing yellow and red.

The colors adjacent to each other on the color wheel are called 'analogous colors'. The colors opposite to each other on the color wheel are called 'complimentary colors'.

You can divide the color wheel into as many divisions as you want and obtain even more subtle shades by combining the analogous colors.

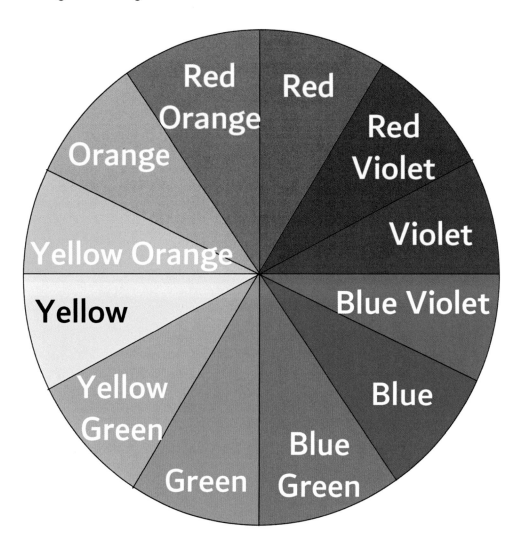

Warm and Cool Colors

Colors are broadly categorized as warm or cool colors.

Red and yellow are warm colors, while blue and green are cool colors.

And then there are in-between colors made by mixing various colors.

Violet is a color made by mixing red and blue. Violet is warmer than the cooler color (blue) and cooler than the warmer color (red).

Each color on the color wheel is either warmer or cooler than its adjacent colors.

Complementary Colors

When coloring an illustration, our goal should be to highlight certain areas and to underplay other areas.

Using complementary colors really helps in this task. In the color wheels shown on the previous pages, the diagonally opposite colors are the complements of each other.

For example, blue and orange are complementary.

Yellow and violet are complementary.

When we use complementary colors besides each other (without mixing them), they 'pop' (intensify) each other.

When complementary colors are mixed, they create neutral colors. Neutral colors are effective in controlling the intensity of colors in a painting.

But why do we need to control this intensity?

When painting an illustration, the artist should set a goal to create a point of interest. If all the colors in the illustration are intense, the viewer will quickly get confused. But if the illustration has a few places with intense colors and the rest are neutral, it creates an ideal viewing experience.

Think of the neutral colors as some in-between calm moments in an action movie and the bright complementary colors as the action scenes. A balance of both is what makes the movie entertaining.

The picture on the next page shows some complementary color mixes. The middle color in each row is obtained by mixing the respective colors from its two sides.

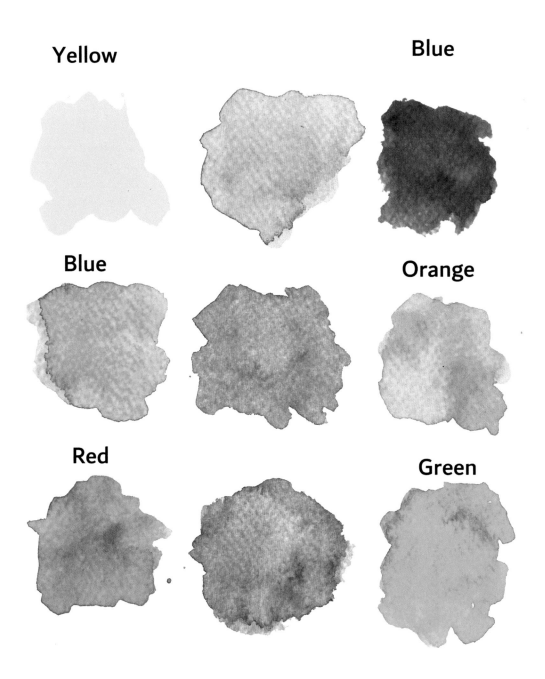

Yellow

Blue

Blue

Orange

Red

Green

The intensity and 'tint' in the mixed color will change depending on which of the two complementary colors is used more in the mixture. It will also be affected by the actual shade of a color being used.

For example, Lemon Yellow and Ochre Yellow will create different tints when mixed with the same colors. If red is used more in the red-green mixture, the resultant shade will look more reddish.

Study the following picture to understand what I mean. The middle two hues are obtained by mixing the left-hand side and right-hand side hues, which themselves are complementary colors.

In the first row, the two hues in the middle are obtained by mixing orange and blue. The second hue from the left-hand side has more blue in it than red. The third hue from the left-hand side has more orange in it.

The same pattern can be seen in the mixing of yellow and violet (row #2) and red and green (row #3).

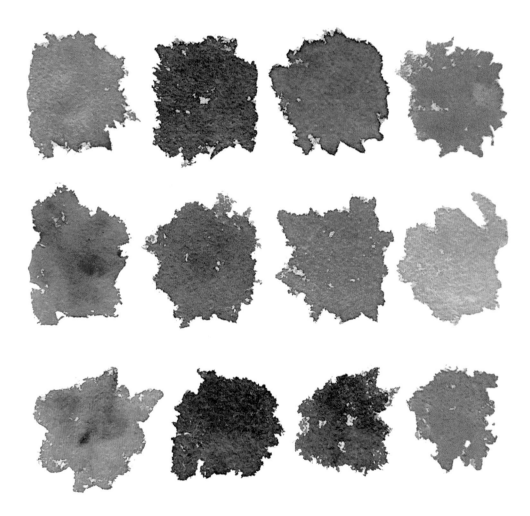

In the rainy cityscape below, observe how the two complementary colors (orange and blue) pop out each other.

While painting, you will be making such decisions about using various color combinations at every step. The use of complementary colors is one of the guidelines you need to think about. But don't be bogged down by this consideration alone.

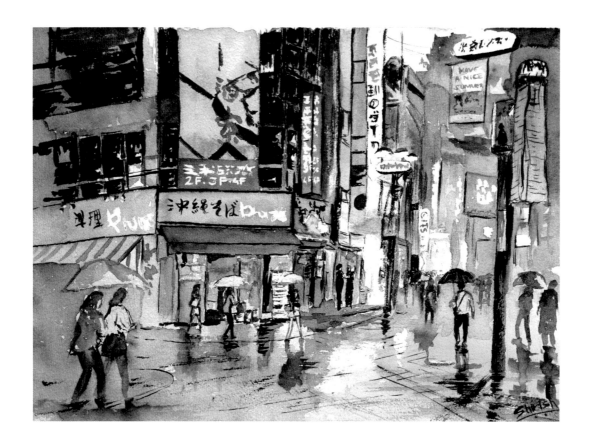

The Colors Used for the Various Paintings in the Book

Below, I have provided a quick reference to the various colors used for the paintings in this book. It's given here for two reasons:

- If you have difficulty recalling the exact color shade when I mention it during a demonstration, you can refer to it here.
- If you do not have the exact color shade with you while practicing, you may choose one of the colors available to you by visually referring to this 'shade card'.

Watercolor

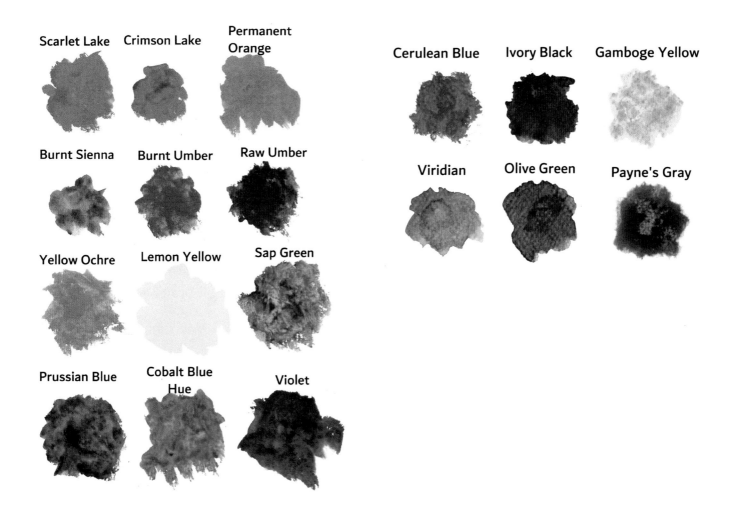

You can also find this shade card at the following URL. Feel free to download it for your reference.

https://www.huesandtones.net/books/wcpreferences.html

INTERESTING AND HARMONIOUS COMPOSITION

Imagine watching a thriller movie. The story goes on like this:

A terrorist organization is planning to wreak havoc on a big metropolis. A special forces team is tasked with finding the perpetrators. They find them without any difficulty and kill them. Everything goes smooth for them, not a hitch. End of story.

Pretty lame, right?

Now imagine watching a horror movie. The story goes on like this:
A group of hot youngsters walk into a secluded cabin in the woods. They find an ancient book which has 'DO NOT OPEN' written on the cover in plain bold letters. So, they do not open the book and have a great picnic in the woods!

By now, you must be wondering if I am truly deranged. But hear me out.

In every book, every movie, every TV/web series, what are the factors that keeps you hooked?

One of the main factors is *tension*.

The anticipation that something exciting/unexpected will happen makes us turn those pages of the book or choose to keep watching that movie without glancing one more time at the social media.

But what if the entire movie consists of nonstop action without a respite of even a second?

I bet it will quickly get tiring.

The ideal thriller book/movie is the one which correctly balances the moments of intense action and the moments of peace.

The same principle applies to a sketch/painting. A sketch/painting must have some 'action' and some 'calm', and both these should balance each other *just* right.

After all, every painting tells a story!

But remember, *these are principles, not rules!*

What's the difference, you may ask?

Principles are like a rule of thumb. When painting, you remember the principles and tailor them to your requirements.

Rules are rigid. There's no place for rigidity in art.

Art is like a flowing river, not a stagnant pond.

In this chapter, we will have a look at some principals which help us achieve the right balance between the 'calm' and the 'storm'.

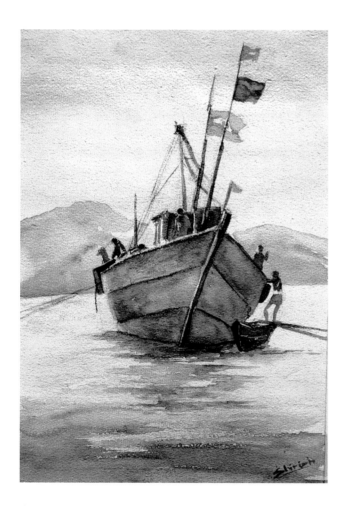

Do you feel the tension in the picture of the boat above? The slight slant of the boat juxtaposed against the distant mountains creates a sense of movement and tension in this painting.

Now imagine if the boat was bolt upright instead of slanting.

Wouldn't it be boring?

I can see you yawning already.

The method I described above (slanting the boat) is just one way of creating an interesting composition. We will learn (with examples) how to do it as we go through this book. After a few paintings, it will become second nature to you.

To hammer this point across, here are some quick and dirty thumbnail sketches for your reference.

What do you see in the painting below as soon as you see it the first time?

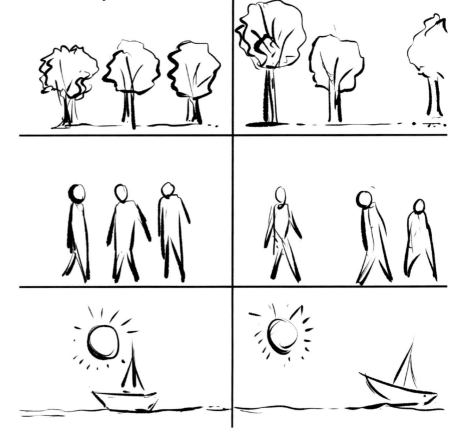

On the left-hand side, you can see the 'boring' composition with no tension. On the right-hand side, you can see the modified composition with some tension.

- In the top example, the tension is created by varying the heights and distances between the trees.
- In the middle example, the tension is created by varying the heights and distances between the people and varying their actions/body language as well.

- In the bottom example, this tension is created by varying the tilt of the boat and shifting the boat to the right third part of the picture.

The second important factor which hooks us into any artwork is *harmony*.

Let's see what the meaning of harmony is in terms of a painting.

Even though a painting consists of many elements, the painting is more than the sum of all these elements.

Was that sentence too heavy? Let me explain.

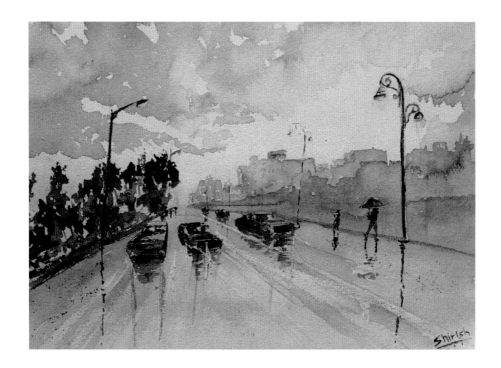

I bet you saw a rain-soaked street with some cars.

Then you saw the lights of the cars reflected on the street below.

Then you saw the receding clouds in the sky.

Maybe then you saw the pedestrians and the streetlights, and then the distant buildings.

Before you label me as a modern Sherlock Holmes, let me tell you how I came to that conclusion.

The human mind is always looking to make sense of the world around it. That's how we maintain our sanity.

When you see a painting (which is just a bunch of color patches on a surface!), your brain forms a picture which makes sense. So, the first thing your brain notices is a complete scene.

Then it starts wandering around and looking for individual elements within the painting.

And you can influence how the viewer's eye moves within your painting. You can achieve this using the right balance (or imbalance) of elements.

In the painting above, the viewer's gaze moves from bottom-right to the top-left along the road. This is because of the way the road creates a slight imbalance in the painting.

Observe this picture.

Now imagine that the thicket on the right-hand side was not present. Instead, there was a blank.

How would the painting look?

A more relevant question would be... how would the painting 'feel'?

To understand this question, let's understand the important role the thicket plays in this painting, even though it's a secondary subject.

Effectively, the thicket 'balances' the painting by countering the tall palm trees. If the thicket was not present, the palm trees would hog all the height and limelight in the painting. The sea would be relegated to the background as a minor element.

The thicket not only makes our gaze linger on the foreground for a fraction more time, but it also creates a 'window' along with the palm trees. This window makes seeing the sea a more interesting experience.

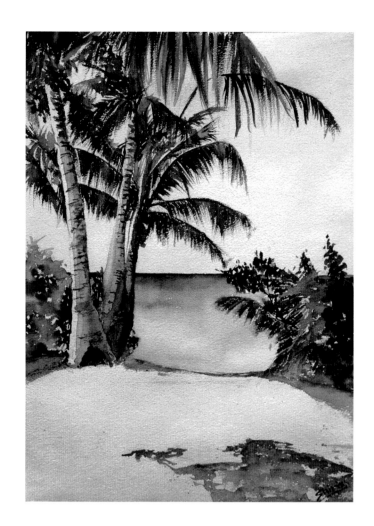

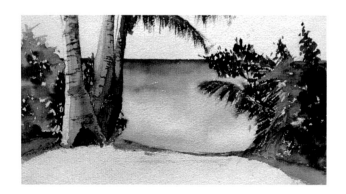

Another element helping to create a balance in this painting is the shadow of a tree outside the picture. In absence of this shadow, the foreground sandy patch would look too bland and empty.

Balance is the trait which brings a certain equilibrium to the painting.

Unity is a trait which brings everything together in a painting. Even though a painting may contain various objects, they all need to work together towards a common goal and focal point.

But how do you bring about unity in a painting?

Well, unity is an intangible concept. So, setting concrete rules for bringing about unity are non-existent.

However, we will see some elements for creating this unity.

A note before you go ahead: *Balance, unity, and all the elements related to composition are highly subjective. It means there's no one right or wrong way to create an interesting composition.*

Multiple artists may find the same scene interesting in multiple ways. Even the same artist may find a different way of depicting the same scene if he/she revisits the scene later.

The only way to find out the right composition for a particular painting is to do it and then do it again if you feel that the first one is not adequate.

In the following pages, I have listed the elements of composition in three dichotomies (pairs of opposing elements). These are not the only elements which make a compelling composition, but they are enough for now.

Dictionary meaning of Dichotomy (once more) – *division into two mutually exclusive, opposed, or contradictory groups.*

Remember that these pairs of elements are not separate from each other. All of them feed into each other. For example, unity is achieved by the right balance and repetition of elements. Dominance is achieved by using contrast and variety.

Let's understand the subject of composition.

Dichotomy 1 – Unity and Contrast

Unity is the quality by which various elements in a painting come together. Think of unity as 'glue' holding all the pieces together.

Contrast is the quality by which some elements in the picture differ significantly from the other elements.

But it seems that these are completely opposite to each other, you may say.

Yes, they are. That's why it's called a dichotomy!

To see how this dichotomy works, see the picture below.

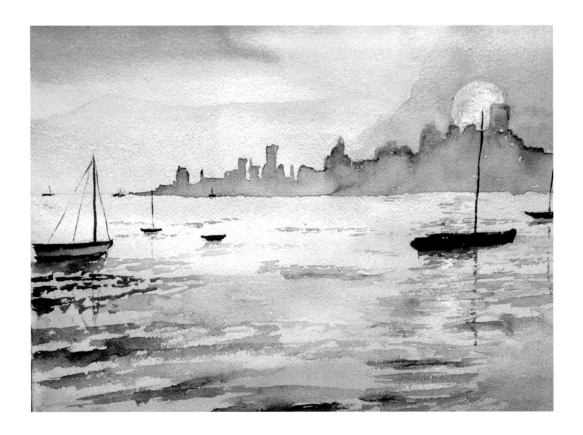

This whole picture has shades of blue which bind the picture. The sky is blue, the distant mountains are blue, the city skyline is bluish, and the water is blue. Thus, the unity is achieved with color.

The contrast is achieved using the shapes of the city skyline and boats.

In the following sketch, contrast is achieved using different levels of detail and thickness of lines. The closer elements are drawn using thick lines and more detail, while the distant elements are drawn using thin lines and minimal detail.

After adding color to this sketch, the contrast is further enhanced by colors. The closer elements are painted using warm and thick colors, while the distant elements are painted using cool colors and pastel shades.

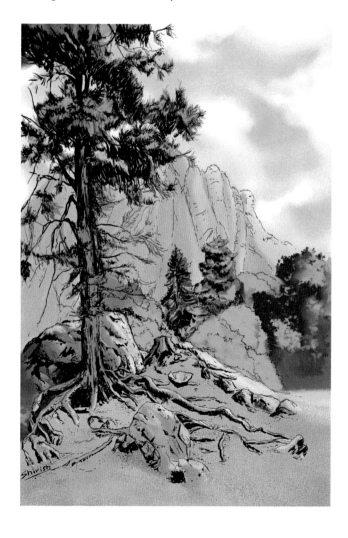

Dichotomy 2 – Balance and Dominance

Balance is the quality by which different elements in a painting prevent each other from dominating the whole composition.

Dominance is the quality which lets a small number of elements dominate the scene.

Let's see how these opposing qualities play out in the painting below:

The picture is divided into three different parts
- The calm water
- The distant mountain ranges
- The stormy sky

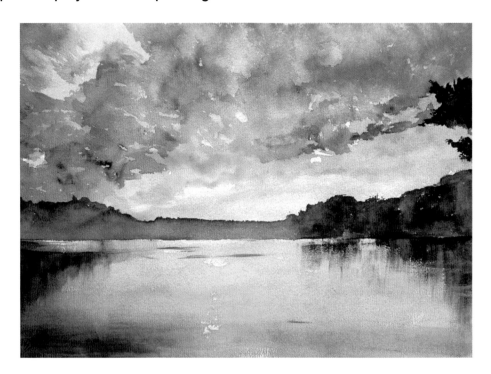

The mountain range acts as a separator and a balancing element between the calm water and the stormy sky. The silhouette of the foliage peeking into the frame from the right-hand side prevents the picture from getting too symmetrical (and boring).

The bright and colorful sky dominates the picture. That's the first part we notice immediately. The bright area in the sky adjacent to the top of the mountain range also grabs our attention.

Remember that if the water was as stormy as the sky in this picture, it would be too much for the viewer to absorb. The calmness of the water allows the sky to dominate the picture.

In this painting, the balance is established using uniform colors for the water and the mountain range. The calm water has been painted in warm colors, while the mountain range is painted in cool colors to make them recede.

The dominance is established using varied colors for the sky. The colors start off warm near the top of the mountain range (which itself is painted using cool colors), and they become cooler at the top. Also, the sky colors are much brighter and more saturated than the warm colors of the water.

Dichotomy 3 – Repetition and Variety

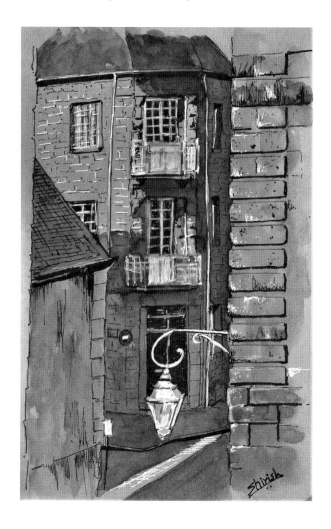

Unless you are double-oh-seven, or someone in a similar profession, at least 90% your life is mundane and repetitive. Work, family, friends, sleep, commute, and daily chores take up most of your time. Think of this as repetition.

Once or twice a year, you go on a holiday, where you are a completely different person to your working self. Think of this as variety.

Imagine if you were on a year-long holiday, or a five-year holiday.

Seems enticing, right? 'Who wouldn't like it?' you may ask.

Let me assure you, you will quickly get tired of the new monotony (repetition) of holiday!

We value holidays so much because they provide a variety from our routine. This variety is valuable because we have a routine!

Similarly, if a painting has too many disparate elements, the viewer will quickly get confused by the variety.

In the above picture, repetition is achieved using the repetitive patterns of the stone and brickwork on the walls, and the doors and windows of the building.

The primary element which introduces variety (and consequently an element of interest) is the streetlamp. The secondary elements of variety are the red-and-white sign near the door and the irregularly shaped shadow falling across the building wall.

An Example of all three Dichotomies together

Let's see how all the six elements of a harmonious composition play out using an example..

In this painting:

Unity is achieved using color. Observe how the painting is dominated by various shades of blue. The primary use of the blue color unites the picture.

Contrast is achieved using some warmer colors such as red and brown. The stark white patches of bright light also provide contrast against the cooler blue shades.

Balance is achieved by balancing the straight lines of the building at the far end of the street with the tapering lines of the buildings on both sides of the street.

Dominance is achieved using the human figures. Being human ourselves, human figures catch our attention first when we observe any artwork.

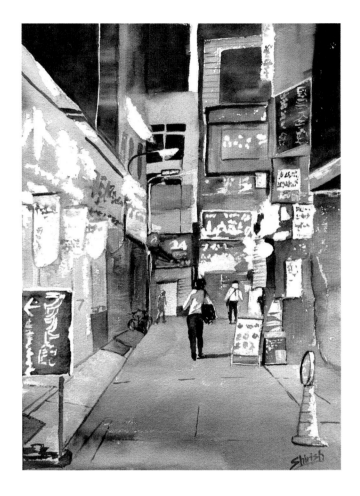

They also make us understand the size and scale of other elements in the painting. The secondary dominant elements in this painting are the bright lights on the storefronts.

Repetition is achieved using the shapes of the elements. You may observe that most of the elements in this painting are rectangular and they form a blocky pattern in the painting. The dominant blue color is also repeated throughout the painting.

Variety is achieved using the human figures, touches of warm colors and the varied shapes of the streetlights, lettering on the storefronts and the cone on the bottom-right.

PERSPECTIVE

The following tips are in no way a comprehensive perspective study. These quick hacks are meant to help you through some of the exercises later in this book.

For the detailed study of perspective, I have written another book, very imaginatively titled 'Composition and Perspective'. You can find it here:

https://huesandtones.net/books/CP/

You can also subscribe to my video training on Composition and Perspective here:

https://huesandtones.net/ArtTrng/CP/

I have uploaded many perspective demonstrations to YouTube, which you can watch on my YouTube channel (**Playlist - Perspective Trainings**):

https://youtube.com/c/huesandtones

One-Point Perspective

When you look at an object from the front, it appears in one-point perspective.

The perspective lines for a one-point perspective are drawn like this. The point where all the perspective lines converge is called the Vanishing Point.

Notice that all the horizontal lines of the doors, windows, and roofs align with the perspective lines. The vertical lines remain perpendicular to the horizon.

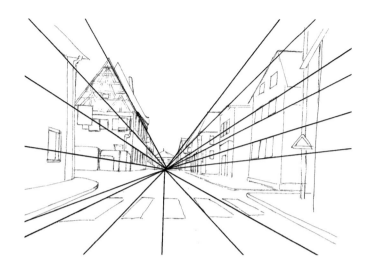

Depending on your position, the vanishing point shifts.

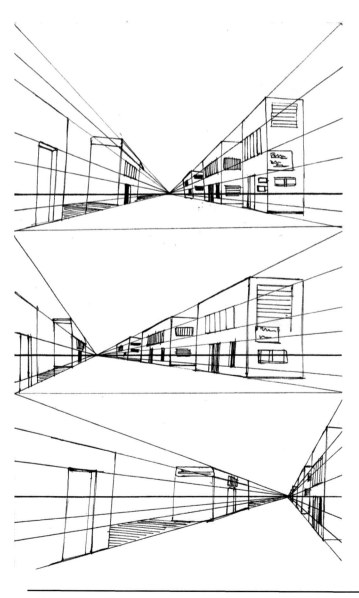

Two-Point Perspective

We will use the two-point perspective concepts in some of the upcoming exercises.

When we can see two surfaces of an object at the same time, we are observing that object in two-point perspective.

We draw two sets of perspective lines for a two-point perspective illustration, considering two vanishing points, one on each side of the object.

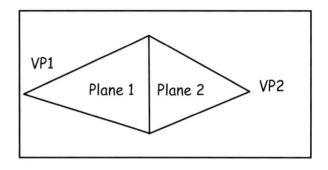

The perspective lines look like this:

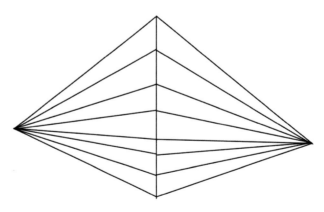

And the object itself will align with the perspective lines like this:

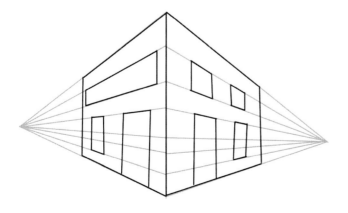

Let's start with a few simple exercises using watercolor.

COLORING TECHNIQUES

Applying Washes

Most watercolor artists begin the painting with color washes. Color washes are useful for 'blocking in' the colored areas in a painting.

Before using the washes in a painting, you should try them out on a separate piece of paper first.

Begin with a monochrome wash. Choose any color. In the example on the right-hand side, I have chosen yellow.

Begin with a light wash from the top. Make sure you cover the whole paper from left to right (or the other way, whichever works for you) with your brush. Use a big, flat brush for this wash.

Wet the brush with clear water so that the color will appear soft on paper. You may want to wet the paper before applying the wash. If so, use a spray bottle to splash water on the paper and then spread it evenly using a big flat brush. You can also wet the paper using a wet flat brush directly.

Vary the density of paint after a few brushstrokes.

Once you reach the edge of the paper, begin the next brushstroke from the edge (left or right) you had begun earlier. The next brushstroke should slightly overlap the earlier brushstroke. The brushstrokes will blend seamlessly if applied wet-on-wet, i.e. the next brushstroke is applied while the earlier brushstroke is still wet.

You may tilt the paper at an angle to make the paint strokes flow better into each other.

There's no pressure to be accurate at this point and you may make as many mistakes as you need. The purpose of this exercise is to get a feel for the wash process. Just keep repeating till you get it to a satisfactory level, and then keep repeating some more before you move on!

Once you are happy with the results of the monochrome study of washes, move to multicolor washes.

In the following picture, I have used blue, yellow and orange hues to demonstrate the multicolor washes. Observe how these washes seamlessly merge into each other. This will require some practice. Just like the previous exercise, keep trying till you get it right, and then try some more!

In the multicolor wash exercise below, you will begin with a cool blue wash at the top, followed by warm hues (yellow and orange) in the middle, and again shifting to blue hues at the bottom.

In the picture below, you will observe a white orb in the middle of the wash. I created this by lifting some paint off the paper. For lifting the paint, gently dab a paper towel on the paint while the paint is still wet. The white paper below will show, creating an illusion of white color.

With a few simple paint strokes, we have created an illusion of some sunlit sky in the top half of the paper and its reflection in the water in the bottom half!

If we really want to convince the viewer that this painting is indeed a sunlit sky with reflections in the water, we obviously need to work more on this. But just putting some washes on the paper has helped us tremendously to begin moving towards that goal.

In the first exercise 'A Serene Sunset' (in the 'Exercises' section later in the book), we will put this technique to use.

Layering and Adding Depth, Atmospheric Perspective

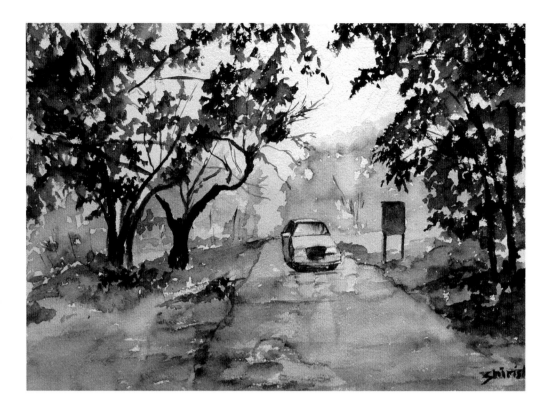

Have a look at the painting above. You will observe that the distant elements in the painting like the foliage are kinda blurred and hazy.

This is done by design.

When observing various objects around us, you will notice that the further away the objects are, the less details are visible to us.

This is because of atmospheric perspective.

The air contains various particles like dust motes, dew drops and pollutants. While looking at the objects in close proximity, these particles do not affect the visibility much. But their effect is much more pronounced when looking at distant objects.

When we use this effect in our paintings, the paintings automatically feel 3D to the viewer since the viewer's brain is trained to equate haziness with distance.

Conversely, the foreground elements are painted in a more detailed fashion to enhance this 3D (depth) effect.

Foreground, Background – Out of Focus Elements, Emphasizing, De-Emphasizing

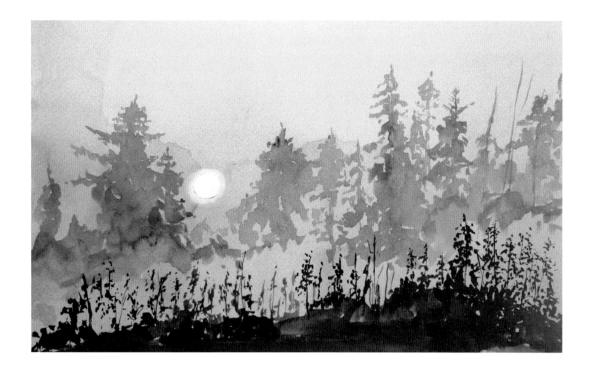

S tudy the above painting carefully.

Observe how the distant tree line is painted in muted shades, while the foreground foliage is painted using darker shades.

But the first element that catches the viewer's attention is the white orb representing the sun.

In this painting, neither the foreground nor the background has many details. In fact, both are painted as silhouettes. The only highlight is the white orb.

Watercolor is an excellent medium for depicting such transitions using the intense colors and dark values in the foreground, and paler colors and light values in the distance.

Hard and Soft Edges

Watercolor is a highly versatile medium. It can be used to paint in a dreamy, soft manner, and it can also be used to paint hard edges.

There's no right or wrong about any of these methods. It comes down to the choice of the artist and the subject of the painting.

Let's see the examples of both these methods.

The painting on the right-hand side is of monsoon season. The atmosphere is hazy with plenty of moisture in the air. The sky is full of rainy clouds. But some light is slowly seeping through the canopy of these clouds. The still water holds the reflections of the trees and the small hut at the water bank.

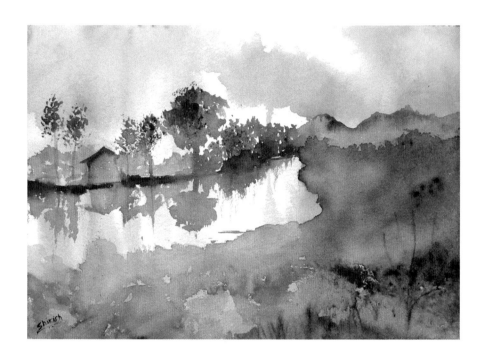

This painting is a natural choice for mostly soft edges. Observe how all the elements seem to be merging into each other. There are no well-defined boundaries between objects.

In the picture on the right-hand side, you can observe that most of the edges are hard. Each house is well-defined and separated from its surrounding houses.

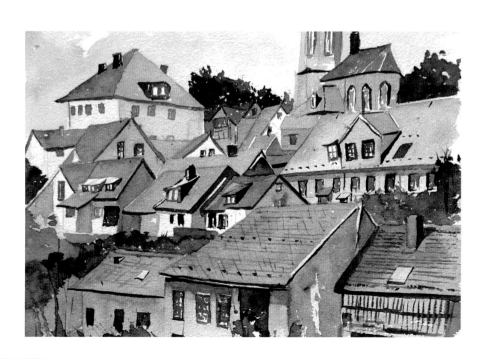

White Areas (Negative Spaces) and Highlights

Painting in watercolor requires a bit of planning. You need to plan where the highlights will appear.

As we learned in the previous chapter, the darkest layer must be on top of the lighter layers. Once an area is painted using dark values, you cannot add a highlight in the same area.

But can I now just paint the highlight area using opaque white color? You may ask.

Yes, you can. With a caveat.

After a few days, the white patches painted over darker shades may start looking exactly like what they are… patches. They won't just blend in with the rest of the painting.

Just like any rule, there are exceptions to this rule, which we will see later in the book. In some exercises, we will make use of the white paint.

So, it's always better to plan ahead and leave the white areas in the painting where you want to have highlights.

There are 2 methods for leaving the white spaces intact.

In the first method, one carefully avoids painting within the white areas. This method is the one frequently used because it creates the most natural-looking highlights with soft edges.

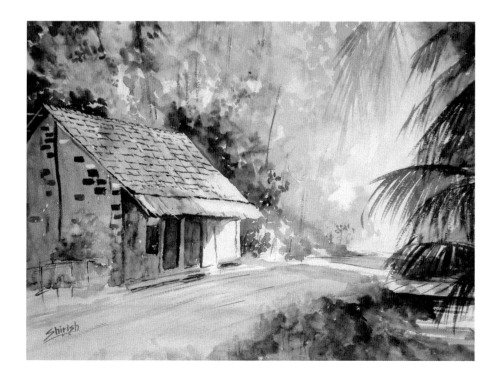

In the painting on the left, the bright diagonal light on the far side of the house wall and the soft light at the right-hand side of the painting are a result of the white spaces left out while painting.

But sometimes, you may need more complex and varied white spaces in a painting.

In the painting on the right, I wanted to create a lot of white spaces indicating bright white lights and reflections. Painting around so many white spaces posed a daunting challenge.

If you attempt to paint around so many white areas, it may be difficult, if not impossible to paint uniform colors. If you decide to paint the washes first and lift out the color from the white-space areas, it's highly error-prone.

So how do you paint uniform washes without sacrificing white areas?

By using masking fluid.

Masking fluid is a thick, white paint-like fluid. It can be applied over paper using a brush or any object like a toothpick, ear bud etc. It's waterproof once dry.

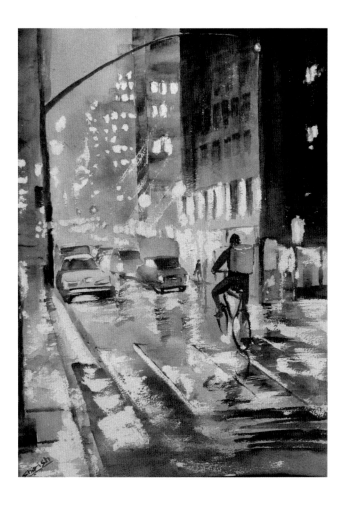

A warning: *If you want to use a brush to apply the masking fluid, use an old brush you won't mind discarding. The masking fluid is not kind to the bristles of brushes.*

Paint the areas where you want to preserve the white spaces using masking fluid. The masking fluid is not entirely invisible. It will show as yellowish patches on the paper. Don't forget to close the lid of the bottle containing the masking fluid. Else it will coagulate quickly.

I have used masking fluid generously in the following painting.

You can see that it's virtually impossible to paint uniform color washes and avoid color seeping into the bright white areas at the same time. I used a toothpick to apply masking fluid where I wanted the light streaks to appear.

Let the masking fluid dry completely before applying washes. The drying time for the masking fluid varies from a few minutes to a few hours. It may take a little more time (even hours) if you have applied the fluid thickly in places. The drying time may also be influenced by weather conditions.

Start applying the washes once the masking fluid has completely dried. You will observe that the paint just flows over the areas where the masking fluid is applied. Some paint will keep floating over the patches of masking fluid, creating weird patterns. Let it be. It won't seep into your painting.

Once the wash has dried, you can remove this excess paint by dabbing it with a paper towel.

Once you are satisfied that all the area not covered by the masking fluid is painted properly, it's time to remove the masking fluid. You can do it using an eraser or your finger. Do this only after the paint is dry, else the paper will get damaged.

One issue with using the masking fluid is the hard edges it creates. If your painting subject demands soft edges, you may want to soften some edges after the masking fluid is removed. This technique is shown in detail in the last exercise in the 'Exercises' section – 'The Waterfall'.

Using a Plastic Wrap for Applying Color

Aplastic wrap is nothing but a small piece of plastic sheet crumpled into a ball.

This is how the plastic sheet looks before crumpling. This is a small piece (about 3" x 3") cut out of a clear plastic bag I received with some packaged goods. The reason it looks so colorful is because I have already used it with paint.

After crumpling the plastic sheet into a random shape, you get the plastic wrap.

Wet this plastic wrap with a little water. Dip it into the paint you want to apply. Then gently dab it onto the paper to apply the color.

We will use this technique in several exercises in this book.

To study how much difference a thick coat of the paint applied using plastic wrap makes, have a look at the photograph below.

On the left-hand side, I have applied some paint on the paper using brushes. I have used 2 colors for this example, Viridian and Yellow Ochre.

On the top right-hand side, I have applied a patch of Viridian using the plastic wrap. In the bottom right-hand side, I have applied a Viridian patch of paint using plastic wrap and applied a Yellow Ochre patch of paint on top of it. I have allowed both these patches to mix and merge, creating some intermediate hues of colors.

Observe how thick and rich the paint patches applied using the plastic wrap look.

Spattering Color

Spattering is an 'exotic' technique which can be used to create creative and unexpectedly interesting effects in a painting.

I will briefly discuss a few spattering techniques that I use. I have also demonstrated some spattering techniques in some of the exercises.

I suggest you try out these techniques separately on a piece of paper before using them in your paintings. It requires nerves of steel the first time you use it! But later, it will become an obsession once you start appreciating how much beauty these techniques add to the painting.

Technique 1 – Flicking the brush

Load a brush with paint. The brush should be slightly damp.

Hold the brush over the area which you want to spatter. You will point the tip of the brush depending on the direction of the spatter you want to achieve.

Then gently use the fingers of your hand (the one not holding the brush) to flick the paint over the paper.

In the following photograph, I am holding the brush with my left hand (not in the frame), while I am flicking the paint with my right thumb and forefinger.

If not enough paint is spattered, it means the brush is too dry. Damp it a little more and try again.

Technique 2 - Spattering Color Using Brushes

Completely saturate a brush with the color you want to spatter the painting with.

Hold another brush over the painting perpendicular to the direction you want to sprinkle the paint.

Hold the first brush (loaded with color) over the second brush in the direction you want to spatter the paint and tap it gently.

In the photograph, on the right, the brush with the blue handle holds the paint.

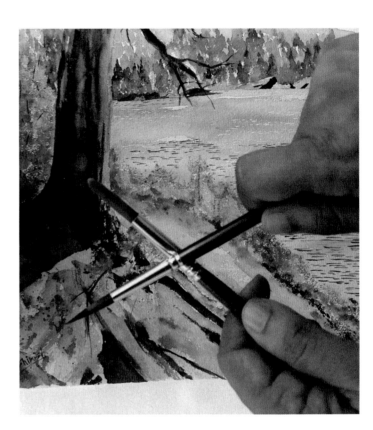

Below, you can see an example of spattering using brushes.

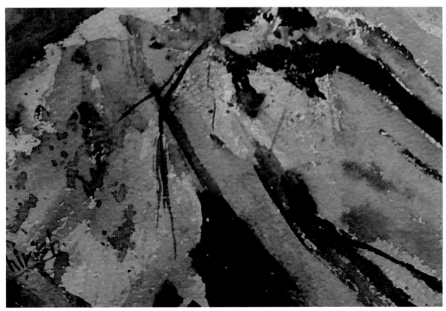

Technique 3 – Spattering With a Toothbrush

I sometimes use a toothbrush to spatter the paint.

When spattering with a toothbrush, it's important to control the direction of the spray. You may want to cover some part of the painting before applying the spatter for better control.

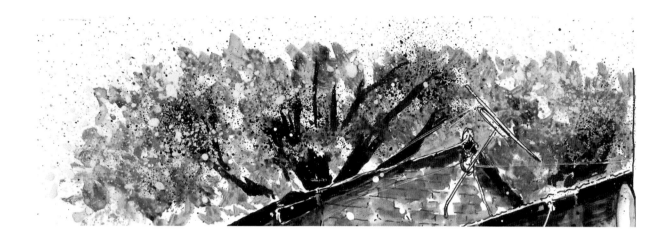

But at the same time, don't try to be too precise. It won't work. The beauty of this technique is its unpredictability. Don't try to spoil it by being a control freak!

To spatter using a toothbrush, first dip the bristles of the toothbrush in the paint/ink. Before removing the toothbrush from the paint, make sure it's not dripping wet with color, else you will make a mess in your workspace and on the paper!

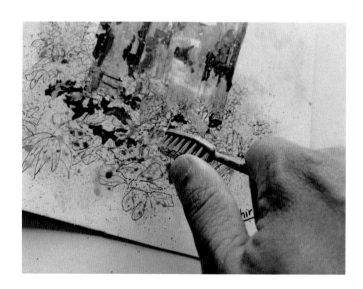

Now hold the toothbrush over the area you want to spatter the color on using your fingers. Hold the brush as close to the paper as you can without touching it to the paper. Use your thumb to gently flick the bristles so the color spatters onto the paper.

EXERCISES

Let's apply everything we learned so far and do some paintings. After all, there is no substitute for some hands-on practice!

At the beginning of each exercise, I will explain which concepts I am going to show via the respective exercise. Each exercise will embody more than one concept, and you may find something I haven't even listed! So, keep exploring.

Each exercise describes in detail not only the techniques and paints that I have used, but also my thought process behind each step and each decision. But remember that this description is meant as a guideline for you. It's not the absolute truth. You are free to make your own decisions, develop your own techniques and even contradict my techniques!

There's nothing right or wrong in art. The most important aspect of art is to enjoy making it.

Each exercise will follow a general guideline as follows:

First, we will draw a rough pencil sketch. I will give you a rough outline sketch to get you started quickly. You may print out the sketch using the URL given at the beginning of each exercise. Then you can trace it for quickly beginning the coloring process.

The sketch will be somewhat like this.

We will begin the coloring process by applying some background washes and blocking in the main shapes.

Then we will define the edges and colors for the main shapes and block the shadows and highlights.

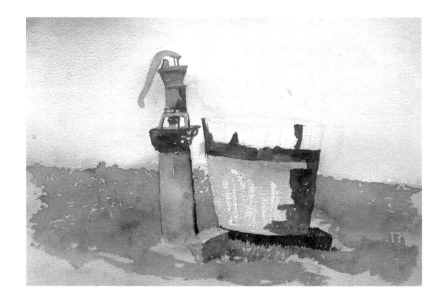

Finally, we will add the finishing touches.

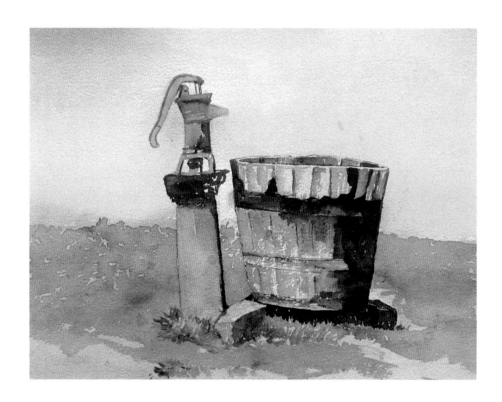

Depending on the complexity of the painting, the steps will very. But this is the gist of the approach we will follow.

Let's begin!

A Serene Sunset

Let's paint this simple sunset painting.

You will learn the following aspects via this painting:

- Painting using a limited palette.
- Using masking fluid.
- Using complementary colors.
- Painting silhouettes.

Let's begin with a simple outline of the basic shapes like this.

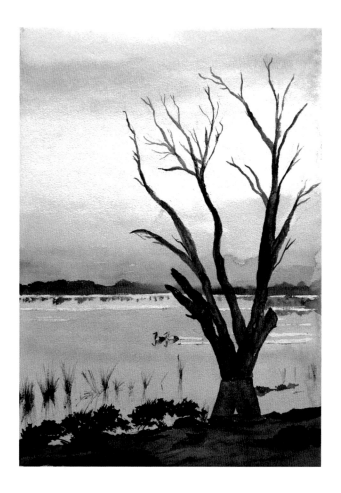

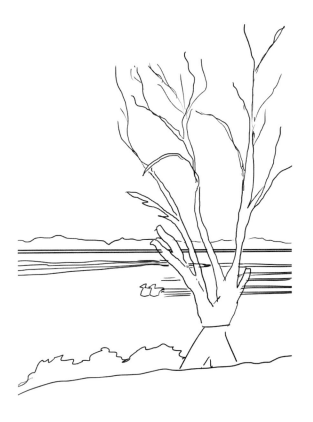

Note: *The outline shown here is drawn using bold strokes only for your understanding. The actual outline should be drawn with a light pencil. The pencil strokes should be so light that they are barely visible when beginning the painting. They will get mostly obscured till the painting is finished.*

You may download the rough sketch and the final illustration from this web page:

https://huesandtones.net/wcpreferences/

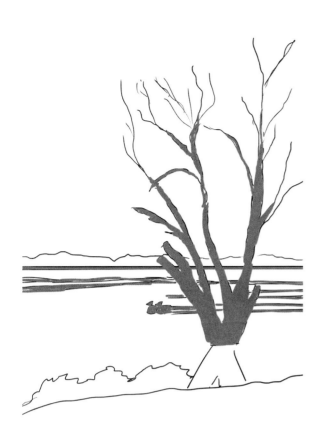

Apply masking fluid over the parts marked in red in the picture on the left (I know it looks a little gaudy, but the important task is to get the point across!).

The horizontal line just below the mountains is almost straight because it's the horizon line. We have kept a line covered in masking fluid just below the mountain so that we can show some shimmer and easily differentiate the water from the mountain range.

These two streaks are created in the following picture because of the ducks. Mark them carefully as shown.

The rest of the streaks are optional. But I suggest you mark three or four streaks randomly to indicate some movement in the otherwise calm water.

Wait until the masking fluid is completely dry. Then move on to the next step.

Normally I wet the paper using a water spray before beginning the wash. In this painting, we want to create a soft transition between the various colors of the sky. You can achieve this better by wetting the paper beforehand, although it's not mandatory.

Begin with a light wash from the top. Use blue hues to do so. I used Cerulean Blue mixed with a little Violet for this top wash.

Make sure you cover the whole paper from left to right (or the other way, or both ways, whichever works for you) with your brush. Use a big, flat brush for this wash. Wet the brush with clear water so that the color will appear soft and diluted on paper.

Once you reach the edge of the paper, begin the next brushstroke from the edge you had begun earlier. The next brushstroke should slightly overlap the earlier brushstroke. If the paper is correctly moistened, these strokes will blend in. This will require a bit of practice. As I suggested earlier, you may want to practice this blending on a separate piece of paper first to get a hang of the process.

As you move downward, change the color to warmer hues.

Note: *When changing the paint, always clean the brush first using water. It's easy to become lazy and load the brush with another color without cleaning it (speaking from experience here!). But if you do this, the colors won't appear fresh on the paper.*

I used Permanent Yellow Deep and a little bit of Permanent Orange for the warmer tones. You will need to do some experimentation before you come up with the right combination of these hues.

Repeat this process for the colors near the mountain range below. But this time, begin with the warm colors and end with the cooler colors.

Keep some blank space between the brushstrokes above and the brushstrokes below. This part will indicate the brightest part of the sky (by using the original white color of the paper).

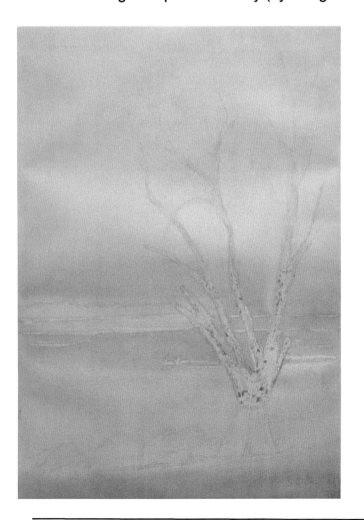

Always soften the edges of the brushstrokes. You can do this by applying a brushstroke at the edge of the colored part with a wet brush without any paint.

For the landmass at the bottom of the painting, I have used a wash using Olive Green.

After the initial wash, the painting will look like this.

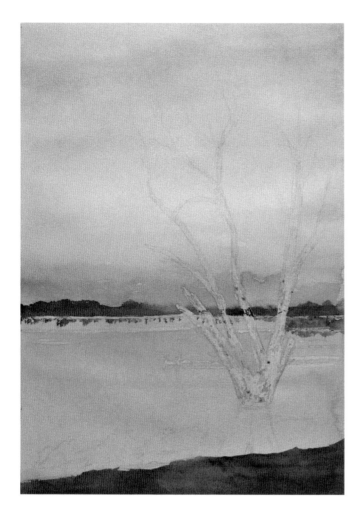

Let's paint the mountains and the landmass first. For the mountains, I used Burnt Sienna, Ivory Black (very small quantity) and Prussian Blue. You may observe that the edge of the mountain is blurred in places. This creates a nice, misty effect.

For the landmass in the foreground, I used Olive Green and Burnt Sienna.

Observe how the reflections of the mountains are painted in the calm water below. There's no need to replicate the details of the mountains in the water. Just some hint of the reflections is fine.

You may use the same flat brush you used for the washes to paint these reflections, or you may switch to round brushes. I used round brushes and painted these reflections using dry brushstrokes. I did this only after the initial wash was completely dry.

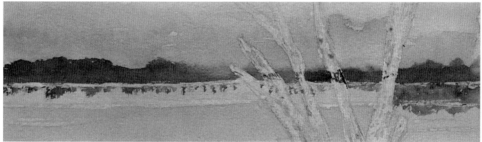

Let's paint the foliage in the water (the first picture on the next page). For painting this foliage, we will use darkest values since we want to show this foliage as a silhouette only. You may use any combination of Burnt Sienna, Burnt Umber, Payne's Gray, Olive Green, Ivory Black etc. to paint this foliage.

The ground is too plain at this stage. Introduce some texture and variety to the ground. I have done this by gently rubbing a dry brush with some dark paint over the ground area and painting some foliage over the ground.

Observe how the grass blades and their reflections are painted in the water using a dry brush.

You may use this same paint to color the dark part of the ducks.

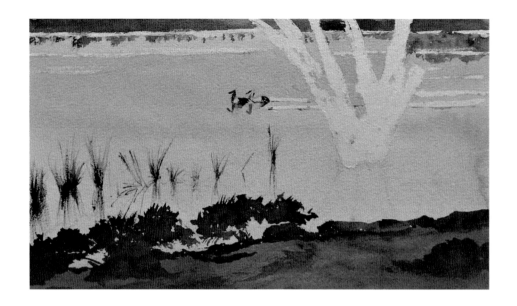

Once we are sure that all the areas except the masked areas are painted correctly, remove the masking fluid using your fingers or an eraser.

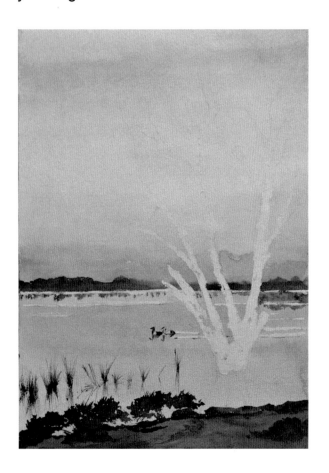

Paint the foreground trees and their reflection. Even though these trees are painted as silhouettes, you still need to show some textural details on them.

For creating these textures, first paint the whole tree trunk using a lighter hue. I have used Burnt Sienna mixed with a little Yellow Ochre for this. After this initial paint is dry, apply a darker hue (I used Burnt Sienna + Ivory Black) using a dry brush over the parts where you want to create a rough texture.

Use the same colors for the reflection of the tree trunk in the water. But keep the texture details to a minimum.

As you go up the tree and paint the thin branches at the top, gradually reduce the darkness of the paint. Since these thin branches are silhouetted against the bright sky, a little light will 'seep' around them, making them seem almost translucent.

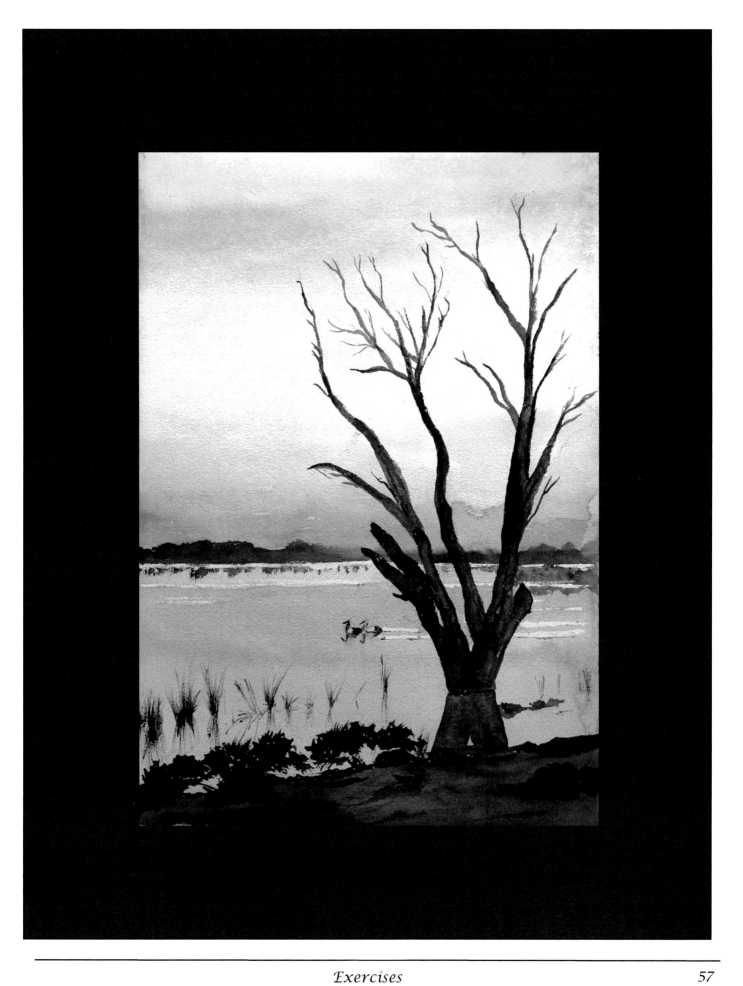

The Twin Trees

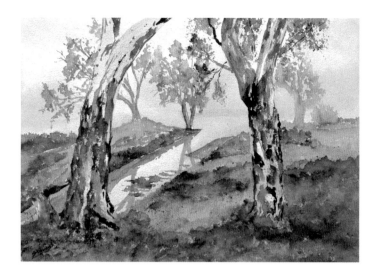

L et's paint these twin trees flanking a calm water body.

You will learn the following aspects via this painting:

- Painting using a limited palette.
- Creating rough tree bark textures.
- Painting reflections in the misty, calm water.
- Creating depth in the painting using soft and hard edges.

You may download the rough sketch and the final illustration from this web page:

https://huesandtones.net/wcpreferences/

Bonus material: You may watch the making of this painting on YouTube by clicking the following link or scanning the QR code below (time-lapse demo at 8X speed).

https://youtu.be/dyOdhRT5tts

Picture References

Let's begin with a simple outline of the basic shapes like this.

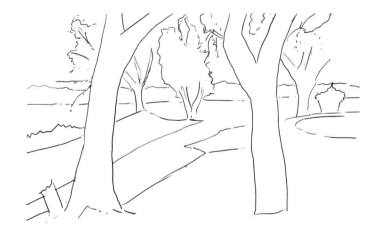

Note: *The outline shown here is drawn using bold strokes only for your understanding. The actual outline should be drawn with a light pencil. The pencil strokes should be so light that they are barely visible when beginning the painting. They will get mostly obscured till the painting is finished.*

Begin with a light wash to cover the paper. I completely wet the paper using a water spray and then applied wash using a wet flat brush. Wetting the paper will enable you to spread the color evenly.

I used Violet mixed with a little Cerulean Blue for the distant mountains. Since this is a misty scene, the visibility of the objects will rapidly decrease with distance. That's why the most distant part i.e. the mountains are painted with ultra-soft edges and are barely visible.

I blocked in the ground portion using a combination of Yellow Ochre and Olive Green.

I kept the area for the foreground trees and the water stream blank. You may find it difficult to leave out these spaces while applying the wash.

If so, just apply the wash over these spaces. While the wash is still wet, gently lift the paint over these areas by dabbing them with a clean paper towel (do not rub the paper towel. It will ruin the paper texture).

Also observe the white space between the distant mountain range and the top of the ground level. This is where the main river is flowing. The water stream we are painting is an offshoot of this main river body.

Begin painting the distant trees. I have used Burnt Sienna mixed with Olive Green to paint the stems and branches, and Olive Green mixed with Yellow Ochre and Payne's Gray for painting the foliage.

Observe how the edges of the trees are softened up. Even though these trees are relatively close to us, they will still appear a bit blurry due to the heavy mist in the air.

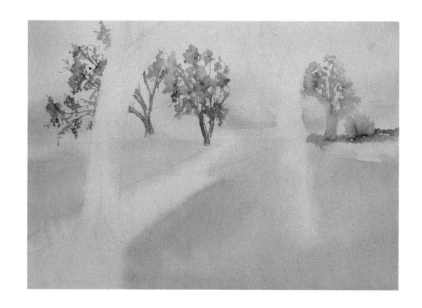

Paint the grassy ground on the left-hand side. Paint the part nearest to the water stream using dark values. This will later bring out the brightness of the water stream.

To paint the grassy ground, I used Olive Green, Viridian, Yellow Ochre and Burnt Sienna. The key is to vary the shades enough to create a feel of various patches of grass. Observe how I have left out some white spaces in the grass too. There's no need to cover the whole ground with color.

This is how the painting looks at this stage.

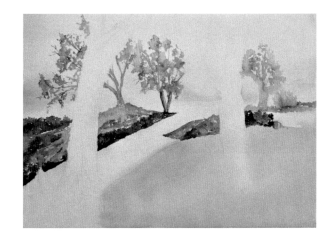

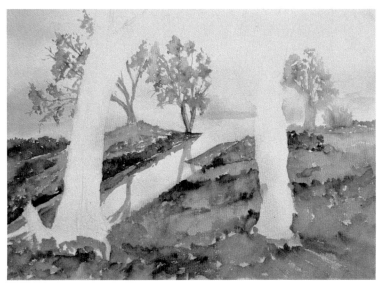

Repeat the process on the right-hand side for painting the grass and foliage on the ground. This does not look very cohesive at the moment since we are covering a larger area. But worry not. The important step is to cover the ground with paint at this stage. We will worry about bringing everything together later.

Paint the reflections in the water. For painting reflections, I used a diluted Payne's Gray. This is a cool bluish hue ideal for such scenarios.

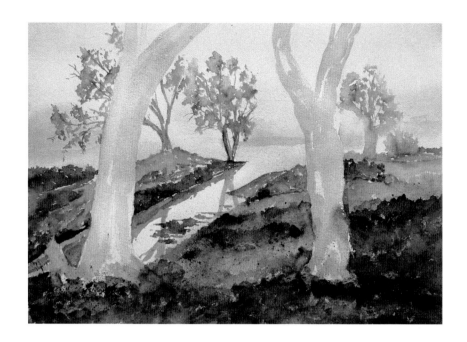

In order to bring some unity to the grassy ground on the right-hand side, I spattered some color over this area using an old toothbrush. Then I further adjusted this color using a brush.

While spattering the color, some color droplets inevitably land into the areas where you don't want them to. Gently dab them with a paper towel to lift them off while they are still wet. If you are too particular about it (unlike me), you may mask the non-spatter area with some paper before spattering the color.

Observe that I have also painted some foliage floating in the water.

In the above picture, the area closer to the viewer is spattered with warm colors (Burnt Sienna, Scarlet Lake). There's a reason to it.

We have seen earlier that the distant objects appear in much lesser detail to our eyes. Their colors also appear cooler. The closer objects appear in much more vivid details and their colors appear warmer. That's why we have painted the ground close to us in warmer hues.

The painting now looks as shown at the top of this page at this stage. The trees closest to us are painted with a thin wash of Burnt Sienna, leaving some white spaces. Let this wash dry before proceeding ahead.

Paint the texture over the trees using a dry brush. I used various colors like Burnt Sienna, Olive Green, Violet, Payne's Gray, Yellow Ochre for painting these textures.

You may choose your own colors. There's nothing right or wrong. Just make sure you leave some white spaces in between. Do not fill the whole area with colors.

Once the tree barks are painted, paint some foliage and branches for the tree on the right-hand side.

And our painting is ready!

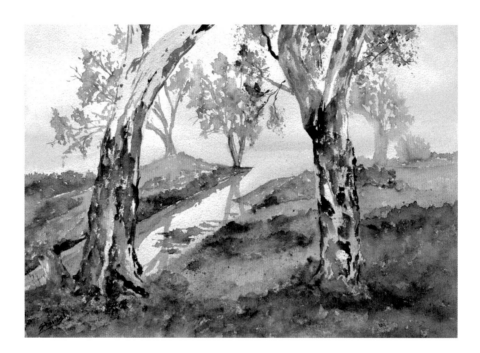

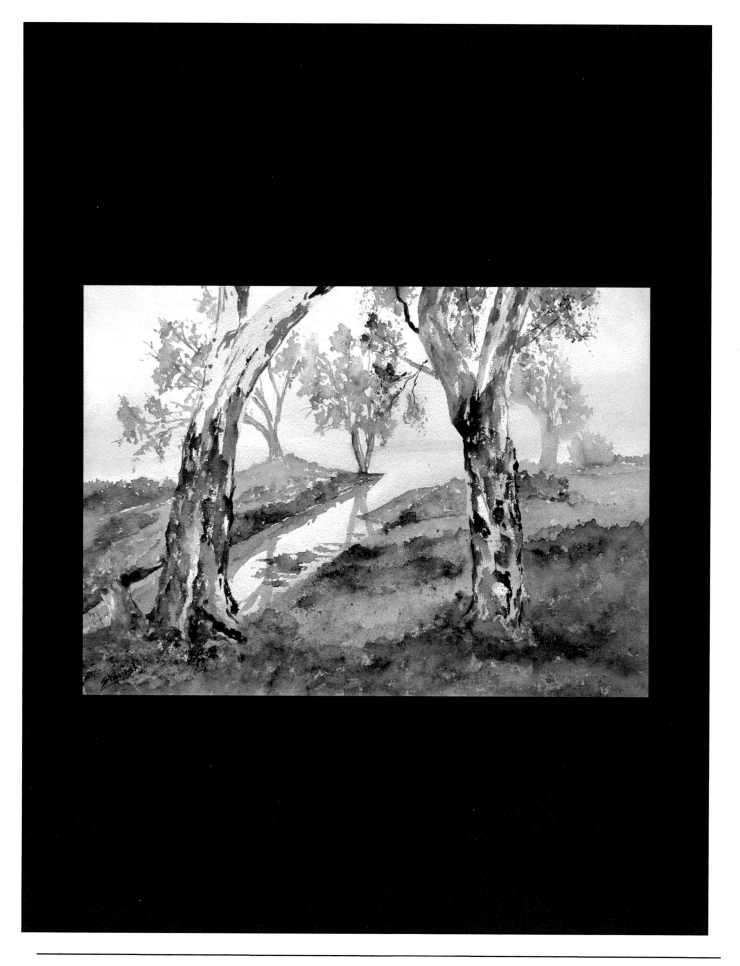

A Still Life Painting

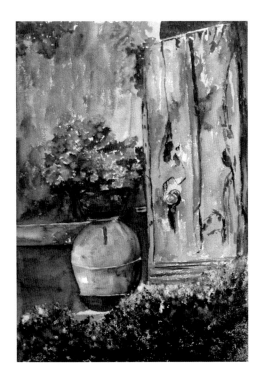

L et's paint this colorful still life painting.

You will learn the following aspects via this painting:

- Creating a rough, weathered texture for the wall and door.
- Creating a feel of foliage and flowers without painting too many details.
- Using complementary colors.

You may download the rough sketch and the final illustration from this web page:

https://huesandtones.net/wcpreferences/

Bonus material: You may watch the making of this painting on YouTube by clicking the following link or scanning the QR code below (time-lapse demo at 8X speed).

https://youtu.be/PHWeeFGRnvM

Note: *The outline shown here is drawn using bold strokes only for your understanding. The actual outline should be drawn with a light pencil. The pencil strokes should be so light that they are barely visible when beginning the painting. They will get mostly obscured till the painting is finished.*

Let's begin with a simple outline of the basic shapes like this.

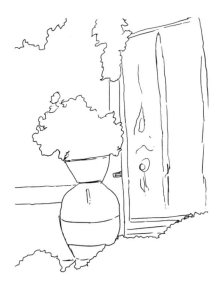

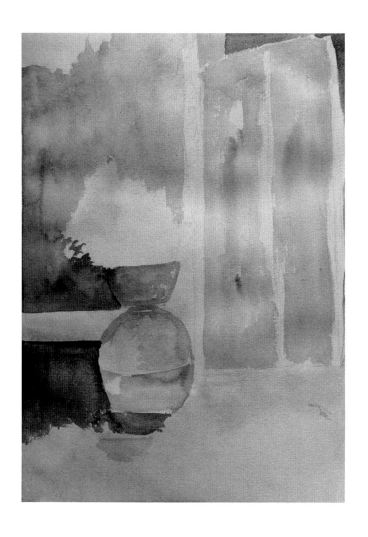

Start by blocking the color patches for the various objects.

The initial washes are lightly applied as always. For the background wall, I used Burnt Sienna, Yellow Ochre and Raw Umber. For the door, it was Cerulean Blue and Burnt Sienna. For blocking the foliage in the foreground, I used Viridian and Lemon Yellow. For the clay pot, I used Burnt Sienna.

Observe all the negative spaces left out for the highlights.

The dark area behind the door is marked using Payne's Gray. This space is important as it essentially frames the door.

Let the wash dry before moving on to the next step.

Begin painting the background elements. Start with the wall. I applied Burnt Sienna, Scarlet Lake and Yellow Ochre using a dry brush and blended these paints on the paper.

Always vary the brush size depending on the area you are painting.

I did not bother to cover the entire surface of the wall. Since I have already applied a base wash, the color will look consistent even though I have left some blank spaces on the door.

Applying the color thickly using a dry brush brings out the rough texture effect on the wall surface.

I wanted a similar rough, abstract effect with the flowers and leaves in the vase.

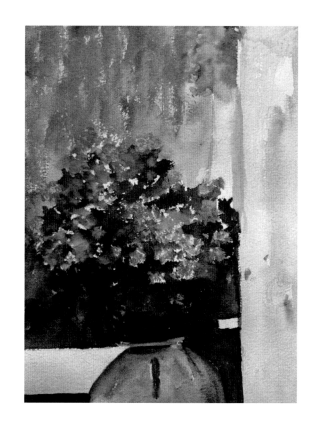

The vase is the only object in this painting with a smooth surface. Everything else has that textured look.

Note the bluish highlight on the left-hand side of the vase.

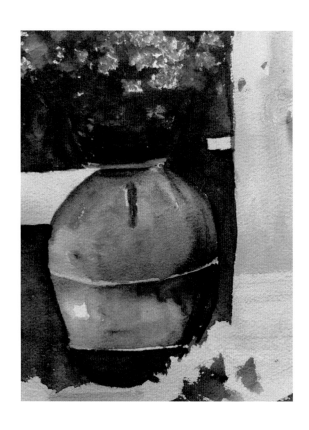

Since the vase has a little bit of luster, it will reflect a small amount of color from its surroundings. The ground is blue, which will reflect a little in those highlights.

Note that keeping the vase surface smooth and other surfaces rough and textured is the choice I made when painting this one. It's not necessary that you imitate me. You may go for an overall smooth look for more objects. There's nothing right or wrong about this.

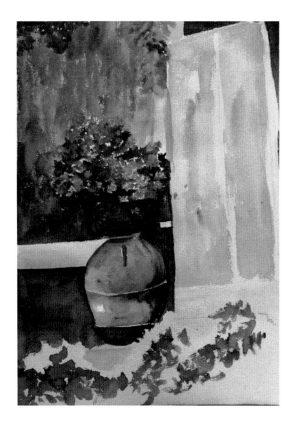

The painting at this stage is shown on the left-hand side. Let's begin working on the door and the foreground foliage.

For the foreground foliage, I took out some Olive Green, Viridian and Lemon Yellow in a color mixing palette. Then I took a small piece of clear plastic sheet. I crumpled the plastic piece, wet it a little with clean water, and dipped it into the colors.

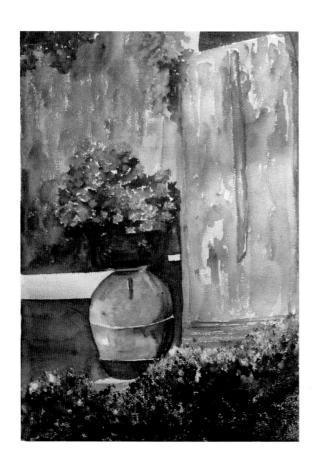

Then I dabbed the paint on the paper. I began with the darkest hue (Olive Green) and worked my way towards the brightest (Lemon Yellow). I did not mix the colors. I just placed the lighter colors over the darker ones and let them do their job.

In watercolor painting, light colors are not easily visible when they are applied over dark colors. To address this problem, I have applied them without mixing with water.

Opaque watercolors are ideal in such cases. But even the 'normal' transparent watercolors can be used in the same way if they are applied directly without mixing with water.

Once the base wash on the door is completely dry, proceed to paint the details of the door using a dry brush. I have used some of the darkest values for depicting the cracks and depressions on the door. Just make sure you don't overdo it! Keep enough blank spaces to make the door interesting.

Add any finishing touches you may desire, and you are done!

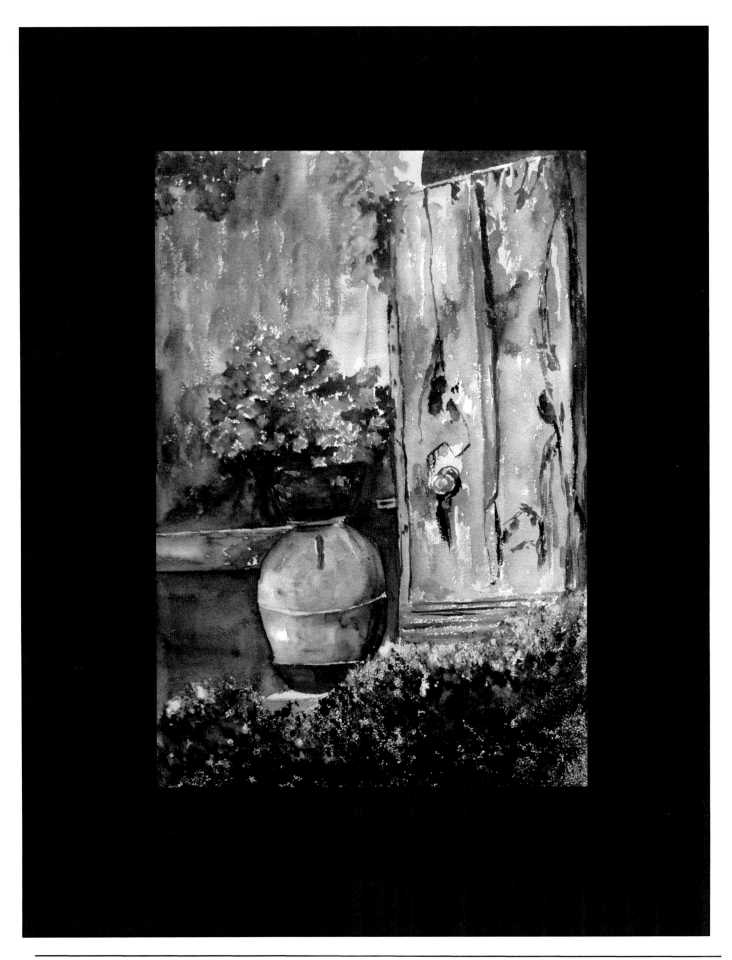

Painting with Watercolor

An Old Wall Covered with Creeper Plants (Vines)

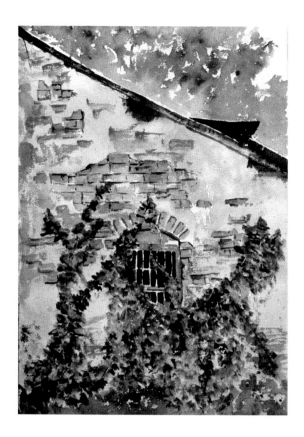

Let's paint this rough, weathered wall partially covered with a creeper plant.

You will learn the following aspects via this painting:

- Painting with a limited palette.
- Creating rough and weathered textures on the wall.
- Using complementary colors.
- Painting broken brick patterns.
- Painting overlapping elements.

You may download the rough sketch and the final illustration from this web page:

https://huesandtones.net/wcpreferences/

Bonus material: You may watch the making of this painting on YouTube by clicking the following link or scanning the QR code below (time-lapse demo at 8X speed).

https://youtu.be/5vPmUw1q7B0

Note: *The outline shown on the next page is drawn using bold strokes only for your understanding. The actual outline should be drawn with a light pencil. The pencil strokes should be so light that they are barely visible when beginning the painting. They will get mostly obscured till the painting is finished.*

Let's begin with a simple outline of the basic shapes like this.

You may observe that there's just too much overlap in this painting. How does one determine how to draw the window, and how much of it to draw?

The ideal way is to imagine how the whole window looks and draw it as if it's not overlapped by the vines at all. Then draw the vines overlapping a part of the window.

If we observe the part of the window visible to us, it's not too tough to extrapolate the rest of the window.

This approach has one advantage. It helps the artist make sure that the proportions of the objects partially hidden behind other objects are rendered correctly. The artist is not left guessing whether the part visible through the overlap is correct or not.

Needless to say, this is just one way of drawing the overlapping elements. If you are comfortable drawing directly what you see, go ahead and do it.

Once the initial drawing is done, wet the paper and apply a light wash over the wall area. Do not worry about painting over some area which is not supposed to have this color. This is a light wash and can be easily painted over later. I used Violet for the initial wash of the wall.

For the foliage at the top-right side of the painting, I used a big brush. The colors used are Olive Green and Burnt Sienna.

We do not want to draw the viewer's focus on this foliage. This is a background element which acts like a frame. It's also useful for defining the edge of the roof. So be reasonably careful not to encroach on the roof when painting near to the roof area.

Once the initial drawing is done, wet the paper and apply a light wash over the wall area. Do not worry about painting over some area which is not supposed to have this color. This is a light wash and can be easily painted over later. I used Violet for the initial wash to the wall.

For the foliage at the top-right side of the painting, I used a big brush. The colors used are Olive Green and Burnt Sienna.

We do not want to draw the viewer' focus on this foliage. This is a background element which acts like a frame. It's also useful for defining the edge of the roof. So be reasonably careful not to encroach in the roof when painting near to the roof area.

Let the wash dry completely before moving on to the next step.

Start painting the wall and the roof. The upper edge of the tin roof is kept blank to indicate a strong highlight. The gap between this tin roof and the edge of the wall below is painted using a combination of Prussian Blue and Ivory Black.

This same combination is used for the hole in the wall.

For the wall itself, apply uneven brushstrokes using a dry brush. I have used Violet for painting these strokes.

Leave out some space where you want to paint the overlapping vines and the window. These spaces need not be precise. We will keep making adjustments as we go on painting.

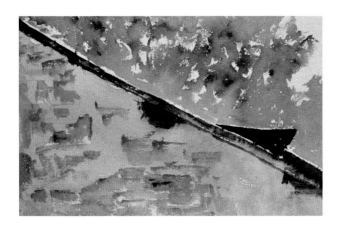

Let's add some details to the part of the wall near the roof. Adding a little shadow as shown creates a thin wooden plank below the roof. Add some strokes with a dark shade vertically on this wooden plank with a dry brush to create the feel of rough texture.

Now block some areas on the wall for the exposed bricks. Use a dry brush, leave out some white spaces, and don't worry about some overlap.

I used Permanent Orange, Burnt Sienna and Scarlet Lake for blocking out the bricks.

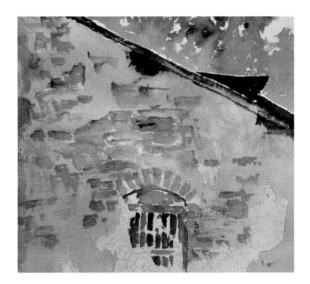

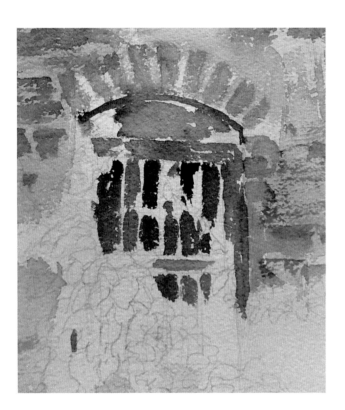

I used Payne's Gray mixed with a little Violet to paint the window. Observe how some white spaces are left out where the iron bars are present and where some vines are likely to overlap the window.

Now we will mark the area and the direction in which the vines have grown over the wall.

It's easy to get lost in the complexity of the vines if we directly start painting them without any direction. But if you look carefully, you will observe that the vines have a particular pattern. We need to capture this pattern, even though we may not paint every leaf individually.

Mark the 'stems' of the vines with light, rough lines as shown below. I used Payne's Gray using a dry brush for marking these vine lines (that actually rhymes!).

At the same time, I have added a few details to the exposed bricks on the wall (see the picture below). There's no need to add too many details. But a pattern should emerge out of the small horizontal and vertical lines you will use to add details.

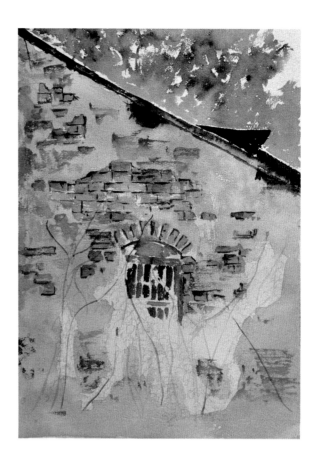

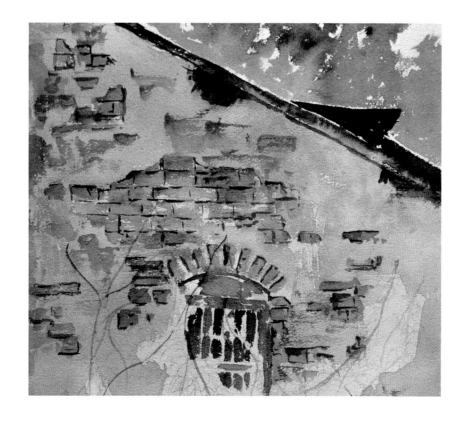

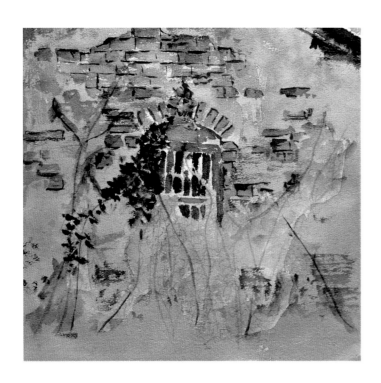

Let's start painting the vines.

First of all, mark the general area where the vines will appear by painting that area with a light wash. I used Viridian for this wash.

Let the wash dry before proceeding to paint the details of the vines.

I primarily used Viridian to paint the vines. For the darkest areas, I added some Ivory Black to Viridian. For the areas where the color was light, I mixed Lemon Yellow with Viridian.

All the while, I followed the lines I had painted earlier for the vines. Observe how the crisscross brushstrokes create an illusion of leaves.

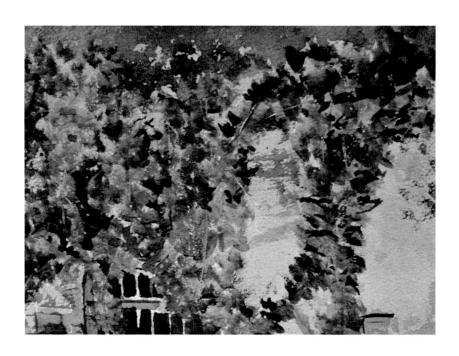

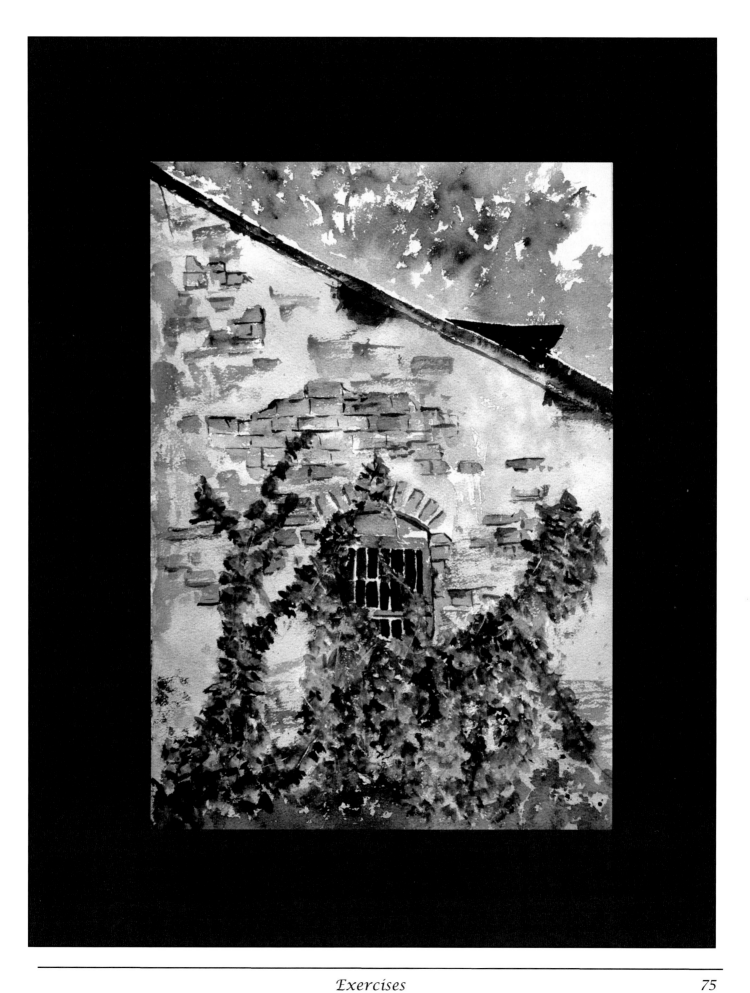

Grass and a Fence

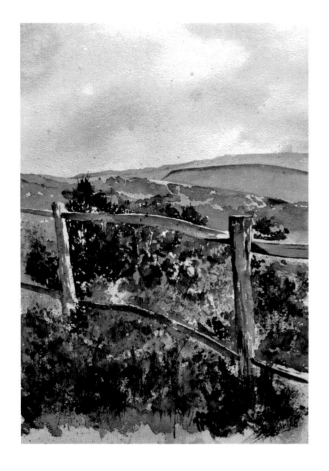

et's paint this fence surrounded by grass and shrubs.

The shapes of the grass and shrubs in this painting are so abstract that sometimes they can feel overwhelming to paint. Where do you start and end a shape? How does one decide upon the distinction of painting well-defined shapes and abstract shapes?

We will cover all these questions in this demonstration.

You will learn the following aspects via this painting:

- Defining abstract shapes like the foliage.
- Creating pure white highlights without using masking fluid.
- Creating depth in the painting.

You may download the rough sketch and the final illustration from this web page:

https://huesandtones.net/wcpreferences/

Note: *The outline shown here is drawn using bold strokes only for your understanding. The actual outline should be drawn with a light pencil. The pencil strokes should be so light that they are barely visible when beginning the painting. They will get mostly obscured till the painting is finished.*

Let's begin with a simple outline of the basic shapes like this.

The goal of this initial outline is to have some reference points for painting. Notice the slight bend in the wood of the fence. This is not the polished wood of household furniture. This is rough, coarse wood, which has interesting textures. It also eliminates the need to be too precise!

Let's begin painting using a thin initial wash.

For the sky, I used Cerulean Blue and mixed a little Violet into it for some variation. I used a big flat brush to paint the initial ultra-thin wash, then added some more color to lend some volume to the sky using a big round brush.

During these steps, I left out some random white spaces to indicate clouds.

To soften the edges of the clouds, I sprayed some water over the paint edges.

Then I gently picked up some color from the middle of the clouds where I wanted them to be completely white. Picking up the paint like this exposed the white color of the paper below.

I used a clean, crumpled paper towel to lift the paint. The way to lift the paint is to gently dab the paper towel onto the damp paint and lift. Never rub the paper towel to lift the paint. Else the paper texture will get spoiled.

You can see here that the sky has just enough variation not to be bland. But it's not the subject of focus for this painting. So, I have painted it minimally.

We have seen an example where the sky is the main subject of interest (in the chapter 'Dichotomy 2 – Balance and Dominance'). But for this painting, this is the only work we will do on the sky.

I painted some patches on the ground using Viridian, Sap Green and Lemon Yellow. These patches are painted using thin washes. Remember, the farthest areas should be painted in minimal details. That's how the viewers' minds will interpret them to be further away.

Let the wash dry before moving on to the next step.

Once the wash is completely dry, paint the distant mountain range and patches of vegetation. For painting the mountain, I used Violet mixed with a small amount of Permanent Orange. The orange color is complementary to violet and tones down its intensity by creating a neutral shade.

For painting the patches of vegetation, I used Burnt Sienna, Viridian, Sap Green and Yellow Ochre. I mixed these shades on paper. I made sure that the paint was just a little thicker over the base wash. We do not want this area to take over the viewers' attention. So, keep it subdued.

Now comes the challenging part. How to paint the thick foliage surrounding the fence posts?

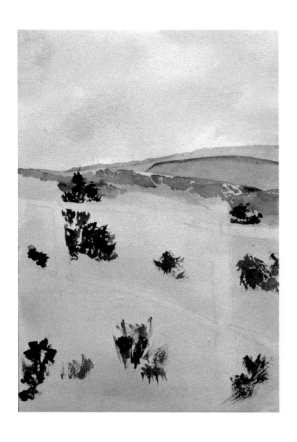

Let's mark some random dark areas first. Use a dark mixture of colors for the dark patches. Below, I have suggested a few combinations.

- Sap Green + Ivory Black
- Sap Green + Payne's Gray
- Burnt Sienna + Ivory Black + Prussian Blue.

There's no rule about which colors should be used here. But a general rule of thumb is not to use a 'pure' color like Ivory Black or Payne's Gray. Mixing a warm and cool color or a pair of complementary colors is fine, as we want to keep this area neutral.

Observe how I have carefully kept the patches from overlapping the fence poles (except at the very bottom).

I began painting one horizontal fence plank using Payne's Gray. But decided to wait until the foliage was completed. You may make such decisions impulsively while painting and they are part of the process. Do not expect everything to be perfect from the get-go. There's no fun in being perfect!

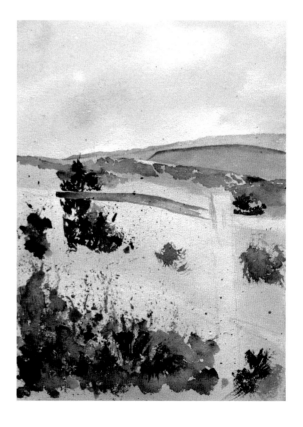

Spatter some color at the bottom part of the painting. I loaded a big round brush with a mixture of Sap Green, Yellow Ochre and Burnt Sienna and flicked a finger over it to spatter the paint.

To understand various spattering techniques you can use, refer to the 'Spattering Color' chapter under 'Coloring Techniques'.

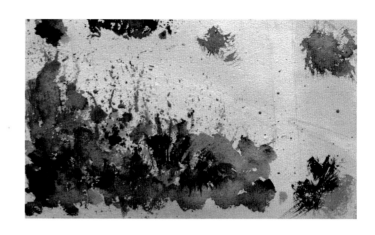

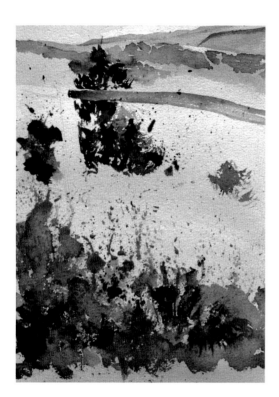

Spattering paint this way is an effective technique here because we are dealing with random shapes.

In the picture on the left, observe how the bush partly overlapped by the fence post is painted such that it touches the fence. Since I want to paint the fence well-lit, I will paint the area around it in dark shades. This will bring out the light even better.

Observe this little white space carefully left unpainted on the upper edge of this plank. This is an important detail in defining the light.

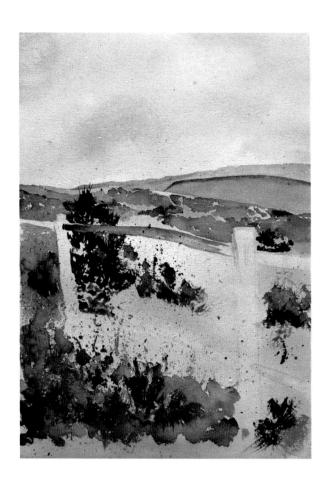

While spattering, it's inevitable that a few droplets of paint will fly on the fence area and even on the sky area, where you do not want them. If you want to completely avoid it, mask these areas using masking tape/masking fluid/a piece of paper beforehand.

I am not really concerned about this though. I simply dabbed the excess paint using a paper towel.

Fill up as much area as you can in-between the fence posts, keeping the fence area clear. Use spattering or directly apply color using a round brush. Just make sure to keep the white spaces intact as shown. If any excess color enters these white spaced areas, gently dab the color using a damp paper towel.

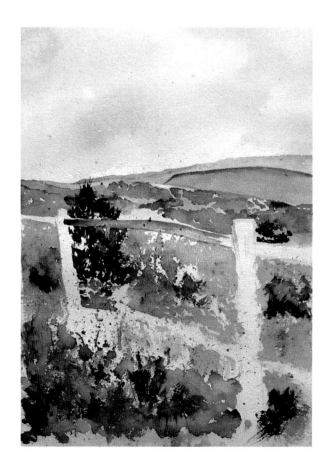

Load a dry brush using a dark color and draw some grass blades and stems for the bushes as shown below. Let some of these stems overlap parts of the fence. These stems will provide a skeleton for the shape of the foliage.

It's time to paint the fence (refer to the picture below).

I have used Payne's Gray and Burnt Sienna to paint the fence. If you do not have Payne's Gray in your arsenal, you may use a bluish color like Prussian Blue or Violet. Neutralize this blue color a bit using Burnt Sienna or another shade of brown (Burnt Umber/Raw Umber). If you want to darken this shade, mix in a little bit of Ivory Black.

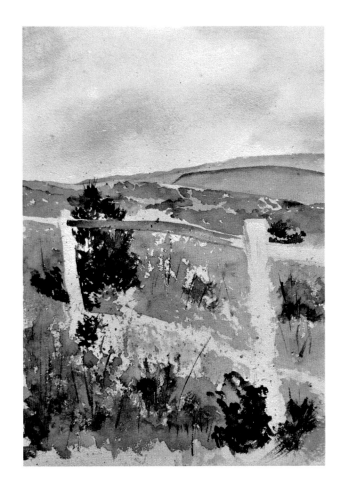

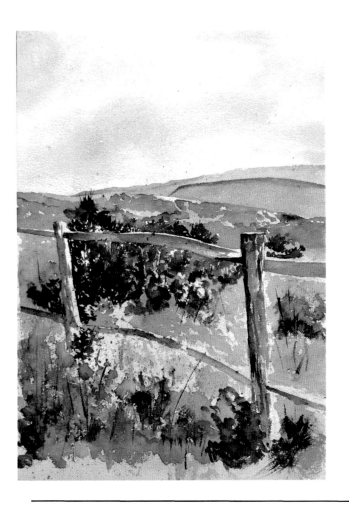

Use a dry round brush to gently paint the fence. Using a dry brush over the rough watercolor paper will produce a broken brushstroke which in turn will create a sense of rough texture.

Use darker shades on the left-hand side and gradually lighten the value as you come towards the right-hand side. The right-hand side edge of the vertical fence posts should be left unpainted to indicate bright light. The same applies to the top edges of the horizontal planks of the fence.

Finish the painting by filling up the empty grass areas, carefully leaving out the fence.

And we are done!

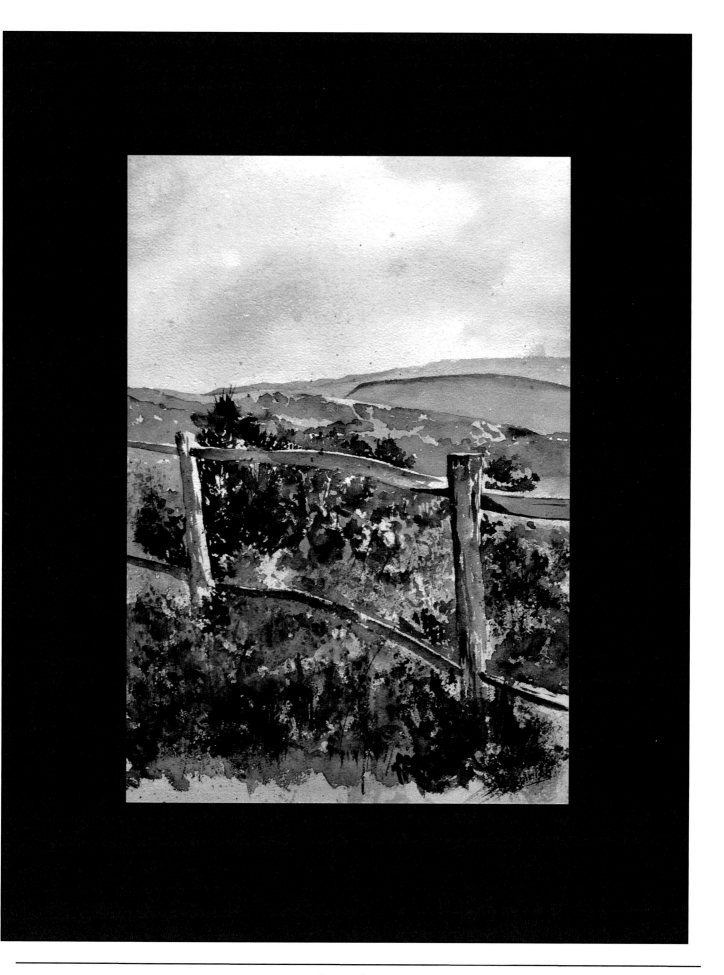

A Waterfront House

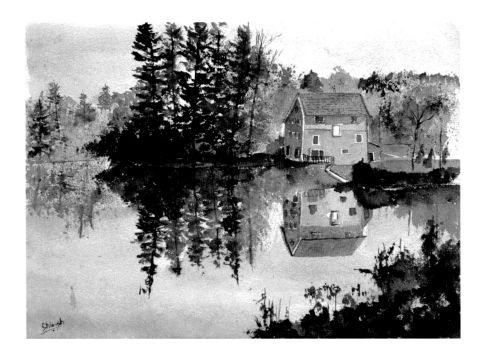

Let's paint this beautiful waterfront house.

You will learn the following aspects via this painting:

 - Painting reflections in calm water.
 - Emphasizing and deemphasizing elements using light and dark values.

You may download the rough sketch and the final illustration from this web page:

https://huesandtones.net/wcpreferences/

Bonus material: You may watch the making of this painting on YouTube by clicking the following link or scanning the QR code below (time-lapse demo at 8X speed).

https://youtu.be/0lo47SO6QUg

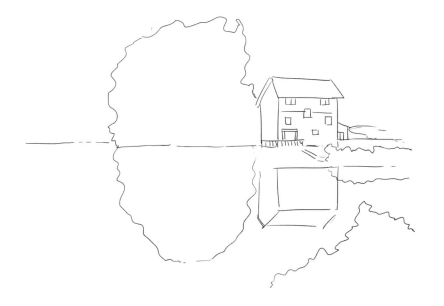

Note: *The outline shown here is drawn using bold strokes only for your understanding. The actual outline should be drawn with a light pencil. The pencil strokes should be so light that they are barely visible when beginning the painting. They will get mostly obscured till the painting is finished.*

You may also notice that there are virtually no details in this rough sketch. Perhaps that's why it is called a 'rough sketch'!

But the wordplay apart, you may observe that the rough sketch blocks only the big masses.

Begin with a thin blue wash for the sky and water. Let the wash occupy more area than needed in the final picture. At a later stage in this painting, we will overlap some of this blue wash with other elements.

I used Cerulean Blue to paint this wash.

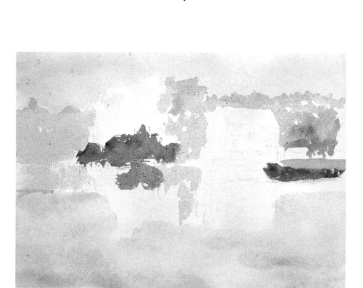

Block the area for the clump of foliage behind the house using large but thin patches of paint. I used Yellow Ochre and Burnt Sienna for these patches. For the darker values, I have mixed Olive Green and a very little amount of Ivory Black.

Use the darkest values to paint the shadowed area at the base of the clump of foliage on the right-hand side, and the tree trunks. Paint the reflections of the tree trunks in the water using the same paint but paint them in the form of broken lines as shown below.

The reflections of the tree trunks should complement the tilt of the stems. If a tree trunk tilts towards the left-hand side, its reflection should tilt on the same side. The relative heights of the stems should also mirror the size of the reflections.

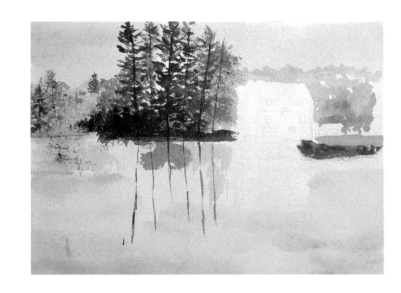

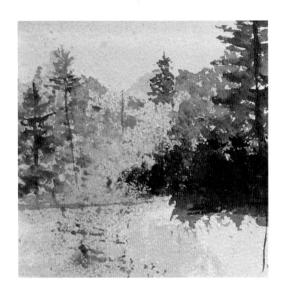

First paint the foliage on the left-hand side using light values. I have used Olive Green and Yellow Ochre to paint this foliage. I dipped a crumpled piece of clear plastic wrap into the paint and applied it on paper to paint the foliage.

Notice that the lower edge of foliage on the left-hand side is slightly above the lower edge of the foliage in the middle and on the right-hand side. This difference between the edges is the visual clue for the viewer that these patches of foliage are at different distances from the viewer.

The foreground (middle) foliage is painted using thicker paint and darker values. For painting the darkest values, I used Olive Green, Viridian Green, Ivory Black and Prussian Blue.

For the lighter part of the foliage at the right-hand and left-hand edges, I used a mixture of Olive Green and Lemon Yellow.

Observe the lower (horizontal) edge of the foliage. It has a slightly lighter value than the base of the foliage. This light value will act as a boundary between the land and the reflection in the water.

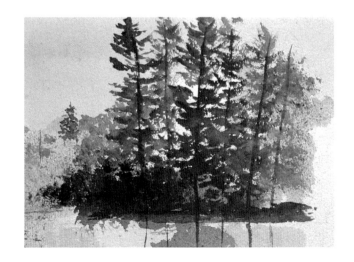

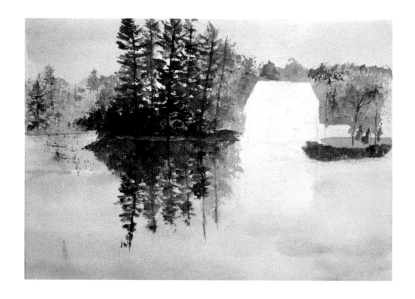

Now paint the reflection of the foliage. The reflection should approximately mirror the foliage. But do not be too fussy about being one hundred percent accurate.

Reflections may appear lighter or darker than the original object depending on the light conditions. In this case, the reflection is slightly lighter than the original object (foliage). The water is very still with no ripples. So, there are no breaks in the reflection.

Using a similar approach, paint the reflections for the foliage on the left-hand side and the right-hand side.

Now, it's time to paint the main subject of the painting... the house!

Just like we started with the foliage, start painting the house using broad strokes of thin paint.

Leave out white spaces for doors and windows as shown. You need not be accurate in blocking these shapes (as shown!).

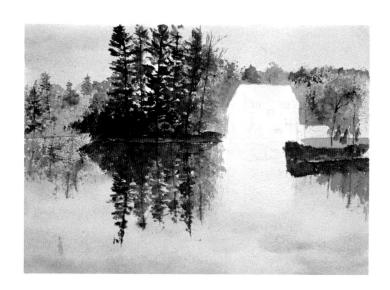

For the rooftop, I have used a thin mixture of Permanent Orange and Violet (Violet being dominant). These complementary colors have created a neutral shade with a slight violet tinge.

For the walls of the house, I used Burnt Sienna mixed with a small quantity of Permanent Orange. Then I used Burnt Sienna to block the shadow area just below the roof.

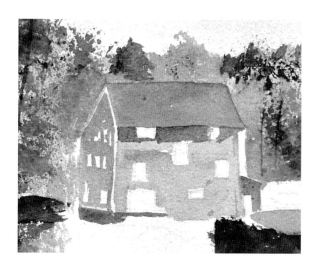

I painted the small outhouse at the right-hand side using Violet. I mixed a little Burnt Sienna to tone down the Violet.

Once the initial paint is dry and you are satisfied with the edges, you may use a slightly thicker paint to re-paint the house. Do this only if you think the house is not 'popping out' enough.

This is how the painting looks now.

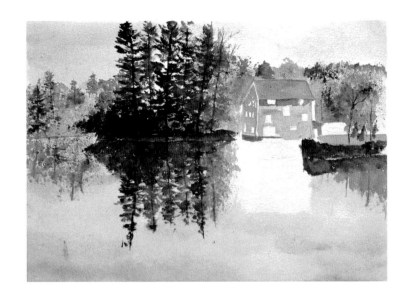

Let's add some details to the house and paint its reflection.

In the picture below, you can observe that three color combinations are used for painting the windows.

The windows facing the maximum light on the front wall of the house can be painted using Cobalt Blue/Cerulean Blue. These glass windows will reflect the sky, which we have painted using Cerulean Blue already.

The uppermost twin windows are in shadows and won't reflect much light. They are painted using Payne's Gray. This color is dark with a bluish tinge. The same is used for the windows on the left-hand side wall of the house. I have even added a touch of Ivory Black to further darken the value.

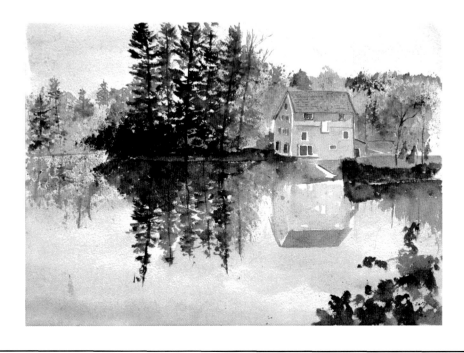

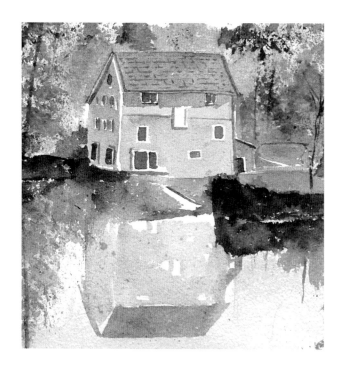

Since the light falls on the house from the right-hand side, the left-hand side edges of the windows and doors will be in shadow. These shadows are painted using a thin shade of Violet. Also note the white spaces left around the door and window frames.

Even the small pathway leading from the house to the water appears to gleam in the stark light because it's left uncolored with a hint of a violet shadow on one side.

Use the same colors used for the house and the roof to paint its reflection in the water. Paint the reflection slightly lighter and leave out some white spaces approximately mimicking the door and windows.

This is how the painting looks now. You may notice that I have also begun painting the foreground foliage on the bottom-right corner of the painting. This foliage will serve as a frame for this composition and will be shown only as a silhouette. I have used Olive Green and Ivory Black for painting this foliage.

Complete the foreground foliage. Add some dark values to the house reflection where windows and doors are mirrored. Add any finishing touches that you can think of.

And our painting is done!

Painting with Watercolor

A Rustic House

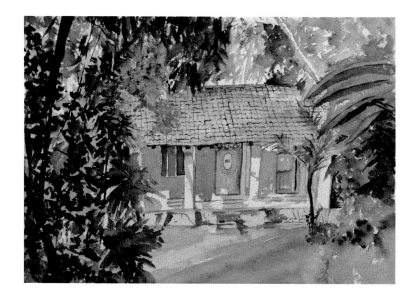

Let's paint this rustic house surrounded by lush greenery.

You will learn the following aspects via this painting:

- Painting greenery with depth.
- Painting complex overlapping elements.
- Using complementary colors.
- Creating a stark light effect without using masking fluid.
- Creating depth using silhouettes and foreground elements.

You may download the rough sketch and the final illustration from this web page:

https://huesandtones.net/wcpreferences/

Let's begin with a simple outline of the basic shapes like this.

Note: *The outline shown here is drawn using bold strokes only for your understanding. The actual outline should be drawn with a light pencil. The pencil strokes should be so light that they are barely visible when beginning the painting. They will get mostly obscured till the painting is finished.*

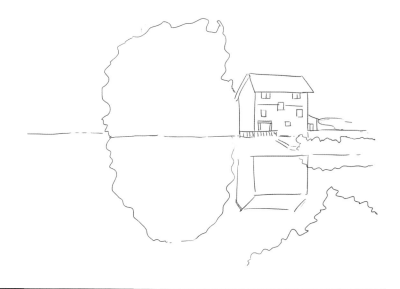

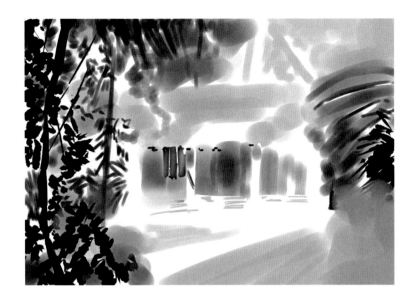

You may observe that there's plenty of overlap in this painting. If you feel overwhelmed by the overlap and think you may go wrong in drawing the basic shapes, I suggest you go through the 'An Old Wall Covered with Creeper Plant (Vines)' exercise earlier in this book first. It has some excellent tips on how to tackle overlap.

Since there are a lot of dark and light elements in this picture, I also did a basic value sketch to nail down where the darkest and lightest values were.

Note: *The value sketch is only a guideline for the final painting and there's no need to be extremely faithful to this sketch while painting.*

Let's begin painting. As we have already learned, the colors of the objects closer to us appear warmer and vivid to us, while the colors of the distant objects appear cooler.

We will paint the distant foliage using Cerulean Blue, Viridian and Prussian Blue. The stems of the trees are painted using Yellow Ochre.

The foliage closer to us is painted using Viridian, Olive Green, Burnt Sienna and Ivory Black.

You may observe that there are some common colors between the distant foliage and the foliage closer to us. However, the colors used for foliage closer to us are painted in a much more vivid and saturated fashion.

Notice the white spaces left out in the distant foliage. We need to leave out these white spaces to make the foliage look believable. They are called 'skyholes'.

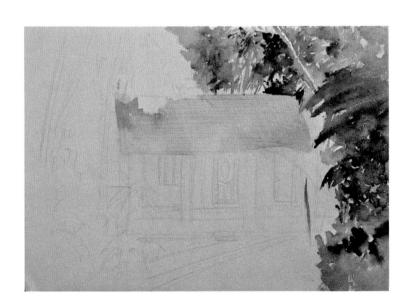

Block the area for the roof of the house using a thin Violet wash.

Block the left-hand side foliage using a light green wash. You may use any hue of green like Viridian, Sap Green or Olive Green.

Again, notice the white spaces (skyholes) left out in the right-hand side foliage.

Start painting the house as per the value sketch. Do not paint over the areas that we have marked as white spaces in the value sketch.

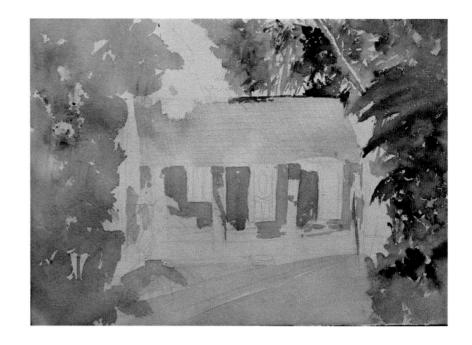

I have used Violet for painting the roof of the house, with a little bit of Permanent Orange mixed in a few places. I did this mixing directly on the paper.

I painted the two doors using Permanent Orange mixed with a little Burnt Sienna to soften the hue (Permanent Orange, if used directly is very bright and may look gaudy). I painted the walls using Violet mixed with Permanent Orange.

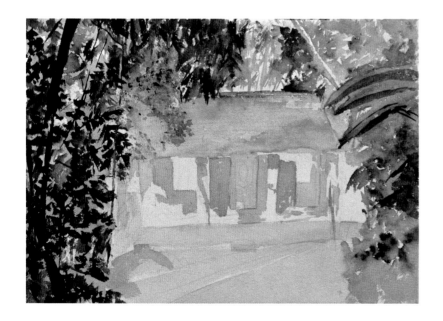

Make sure the base wash for the foreground foliage on both sides is dry before proceeding.

Add the darkest values to the foreground foliage on both the sides. This will create a nice frame for the main subject of the painting i.e. the house.

For the dark values, I mixed Olive Green with Ivory Black and some Payne's Gray. The lighter values are obtained by mixing Olive Green with Lemon Yellow.

Do not darken the whole left-hand side foliage. Leave a little mid-tone values (not-too-dark and not-too-light) in-between. This will create some depth in the foliage too.

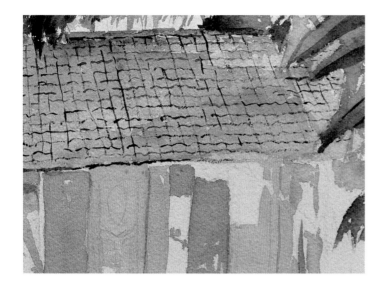

Add a little detail to the house. Paint some shingle patterns on the roof using a dark hue. Don't paint them too precise. A feel of the roof shingles should be enough.

Paint the windowpanes using dark hues. I have used Payne's Gray and some Prussian Blue for this. Note the white lines indicating the separation between the three windowpanes.

Add some details to the house. Use dark hues like Burnt Sienna and Burnt Umber to paint the shadows in the warm areas. To paint the shadows on the steps, I used Violet mixed with Prussian Blue.

Fill the vacant places between the foliage and house by painting some additional foliage. Add some texture to the ground using dry brushing. And our painting is ready!

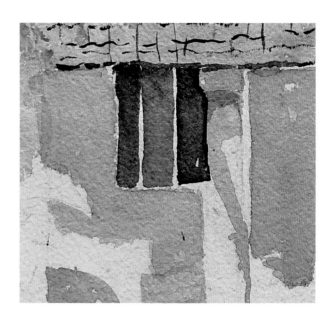

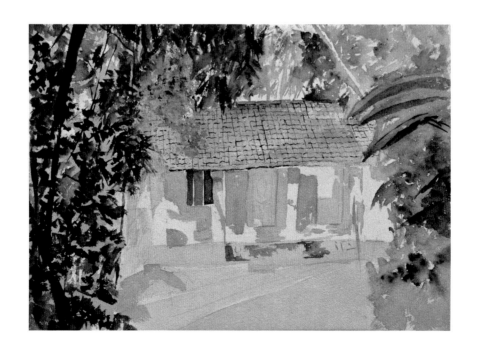

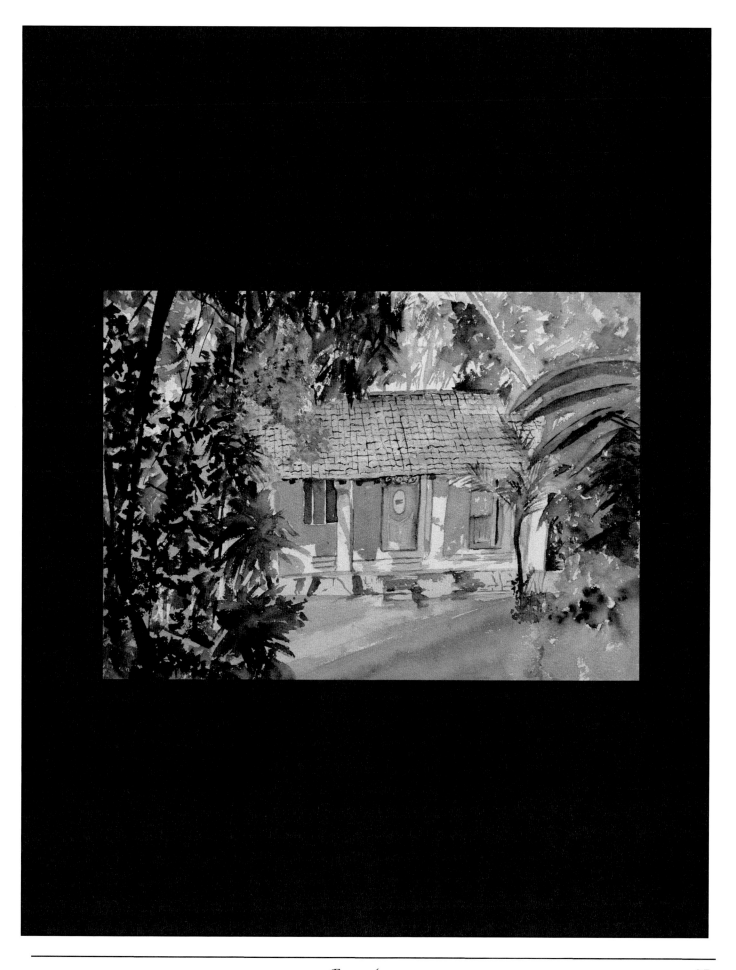

Cabin in the Snow

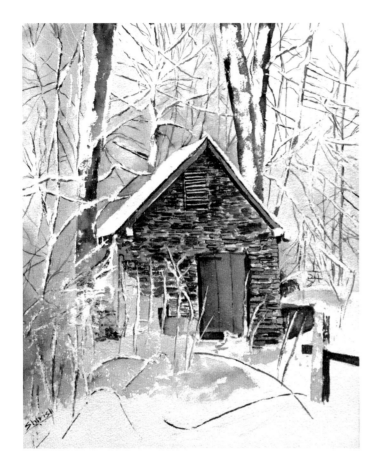

Let's paint this cabin surrounded by snow, and a whole lot of twisted shrubs.

You will learn the following aspects via this painting:

- Painting complicated negative spaces.
- Using a dash of colors in an otherwise monochrome landscape.
- Preserving white spaces using masking fluid.

You may download the rough sketch and the final illustration from this web page:

https://huesandtones.net/wcpreferences/

Let's begin with a simple outline of the basic shapes like this.

Note: *The outline shown here is drawn using bold strokes only for your understanding. The actual outline should be drawn with a light pencil. The pencil strokes should be so light that they are barely visible when beginning the painting. They will get mostly obscured till the painting is finished.*

You may observe that the shrubs and trees in the background (and even in the foreground) are a jumbled mass. This can be distracting and looks complicated. These shrubs are mostly white. How do we 'paint' these shapes if they are white against a white background?

We will see how to simplify these shapes and interpret their colors so they can be painted in a way that the viewer understands them.

Let's begin applying the masking fluid. I used a brush to apply the masking fluid in the broad areas and used a toothpick to apply the masking fluid in the narrow spaces.

In the picture on the right-hand side, the area covered by masking fluid is showing as yellow. You can see that the painting looks plain ugly at this stage. But don't worry. This too shall pass!

I have not covered the entire white area in the painting with masking fluid. The primary purpose of applying masking fluid is to protect the overlapping areas from being accidently painted over. So, the masking fluid is mostly applied on the area where overlaps are rampant, or where I want to strictly prevent the paint from seeping into shapes (like the snow-covered roof).

Now start applying some background color. I used Payne's Gray for the background here. This color is a neutral tint. Its dark bluish hue is perfect for the grey background.

If you do not have Payne's Gray in your coloring arsenal, worry not. You can create a similar tint by mixing Prussian Blue and Burnt Sienna.

Note the white spaces left in-between. Do not fill out the entire background. Let some light seep through!

Start painting the foreground tree trunks. I again used Payne's Gray, but in a saturated form using a dry brush. I also mixed a small quantity of Ivory Black to Payne's Gray to make it darker.

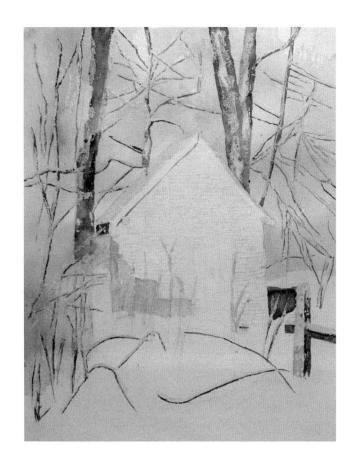

When painting the tree trunks, paint using smooth, continuous strokes. Do not try to paint around the area covered by the masking fluid. Paint over this area. This way, the brushstrokes will look natural.

Enabling us to paint with such natural strokes is the whole point of using the masking fluid!

Observe how the dark outlines of the branches hug the areas covered by the masking fluid.

Try to imagine how these will look once the masking fluid is removed. Remember that the area currently covered by the masking fluid will look completely white once the masking fluid is removed (even though it looks a sickly yellow right now).

Block the base color for the cabin. Remember that the cabin has all the warm colors, which will contrast in an excellent manner against the cool, neutral background and foreground. We will use Yellow Ochre and Burnt Sienna for the base wash for the cabin.

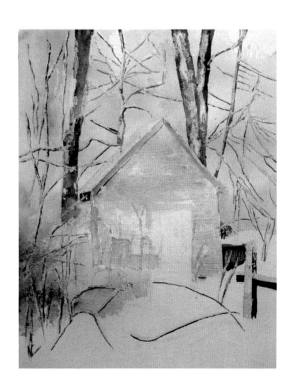

Let this wash dry completely before proceeding to the next stage.

For painting the brick pattern on the cabin walls, I have used various warm colors. The way to paint this seemingly complex pattern is as follows:

- Load a brush with one of the colors you want to paint this pattern.
- Paint some random bricks on the wall using this same brush at various places. Paint some adjacent bricks. Paint some distant bricks. There's no fixed pattern to this.
- Repeat the above steps using different colors.

I used the following colors for these bricks
- Yellow Ochre
- Burnt Sienna
- Crimson Lake
- Permanent Orange
- Crimson Lake + Ivory Black
- Burnt Sienna + Ivory Black

For painting the door, I used Crimson Lake mixed with Burnt Sienna.

Below is the painting after the masking fluid is removed.

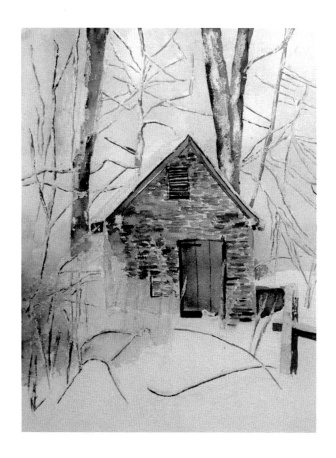

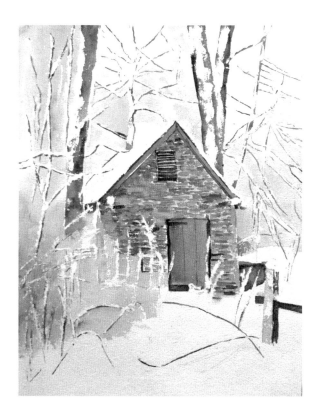

Focus on the cabin wall and add any finishing touches you desire. This wall is the focus of this painting and you may spend as much time as you want on this.

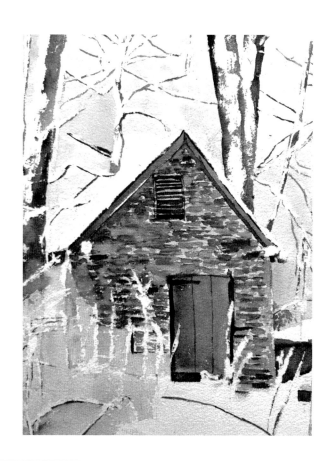

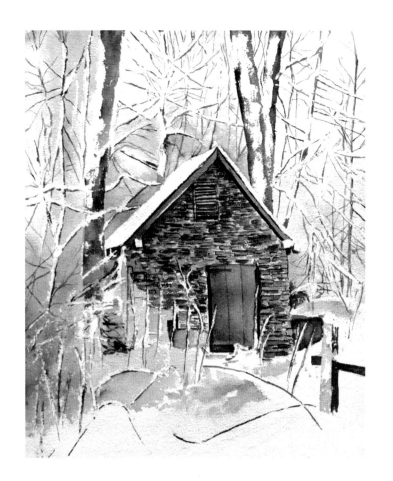

At this stage, I realized that the background of the house did not contrast so well with the white snow-clad roof of the cabin. To bring out the extreme white of this roof, the background needed to be darker. So, I carefully added some darker tones of Payne's Grey to the background. It would be easier to do while the masking fluid was still present on the paper. But sometimes, one must make improvisations in the later stages of a painting.

I also added some more branches in the background using Payne's Gray, creating a complex pattern of tangled branches. This step is optional. If you find this step too complex, just skip it, or paint only as many branches as you are comfortable with.

While painting the branches behind the white roof, make sure no part of any branch encroaches upon the white part of the roof. Remember, these branches are behind the roof.

To show some fine branches and for adding finishing touches to the branches overlapping the brick wall, I used a white gel pen. I used the same gel pen for the window slats.

If you want to use a gel pen like this, make sure the paint is completely dry before you begin.

'But doesn't using a pen while painting a watercolor amount to cheating?' you may ask.

Maybe.

But I never was a sucker for rules anyway! So, I can live with a little cheating!

For adding the finishing touches, I generously spattered white poster paint over some parts of the painting, (mostly) leaving out the cabin wall.

And our painting is ready!

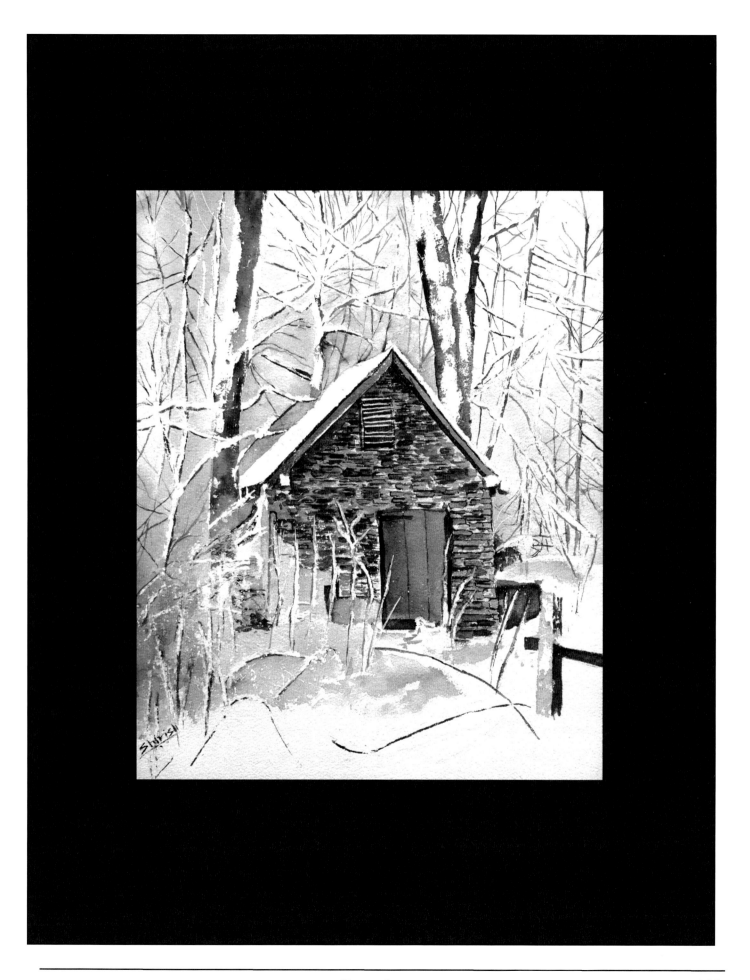

Autumn Tree Near a Lake

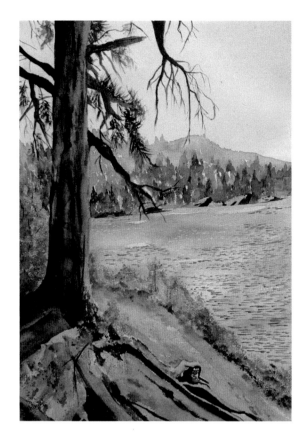

L et's paint this tree near a water body.

You will learn the following aspects via this painting:

- How light and shadows affect the colors of an object.
- Painting slightly moving water with ripples.
- Applying opaque layers using transparent paints.

You may download the rough sketch and the final illustration from this web page:

https://huesandtones.net/wcpreferences/

Let's begin with a simple outline of the basic shapes like this.

Note: *The outline shown here is drawn using bold strokes only for your understanding. The actual outline should be drawn with a light pencil. The pencil strokes should be so light that they are barely visible when beginning the painting. They will get mostly obscured till the painting is finished.*

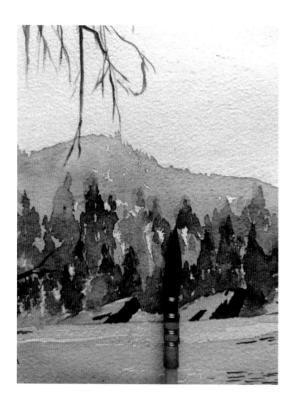

Begin with base washes as follows.

- Burnt Sienna for the land and tree trunk.
- Viridian, Prussian Blue and Yellow Ochre for the mountains and distant trees.
- Cerulean Blue for the sky and the water. The water also has some greenish parts, which were painted using Viridian.

Note some white spaces left out for the water ripples at the far side of the stream.

For painting the trees fronting the mountains, I used a different brush technique. Normally, we use the tip of the brush to paint. But in this case, I touched the entire brush flat to the paper as shown on the left-hand side.

This created the vertical paint marks as shown in the picture below.

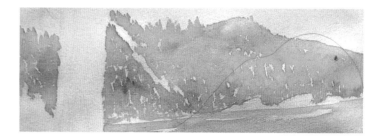

Notice that I have left some white spaces below the tree line in the picture above. This white space is for painting some rocks.

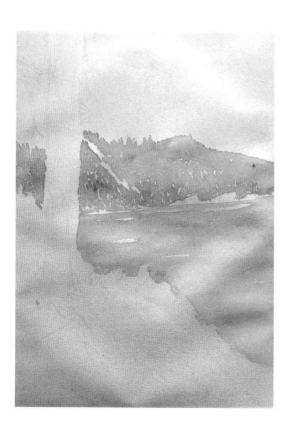

Let's begin lending some texture and character to the tree trunk.

The main base color used for the tree trunk is Burnt Sienna. For the dark tones, I have used Payne's Gray and for the lighter tones, I mixed some Yellow Ochre with Burnt Sienna. The upper-right hand edge also has some Violet hue.

You may notice some additional tree shapes and rocks at the far side of the stream.

We are creating additional layers within the tree line so it won't look like an unintelligible flat silhouette.

The dark trees bring out the lighter rocks clearly. For painting the dark tress, I have used Olive Green and Payne's Gray. For the rocks, it's primarily Yellow Ochre mixed with a little Burnt Sienna.

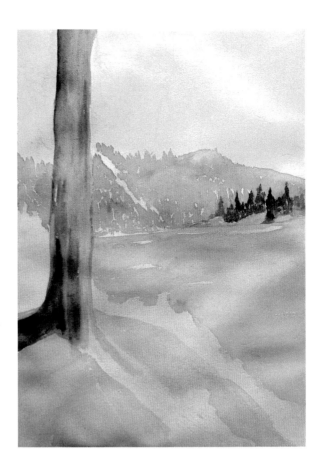

Be careful with the lower edges of the dark trees. They should not encroach the edges of the rocks. The rocks are in front of the trees.

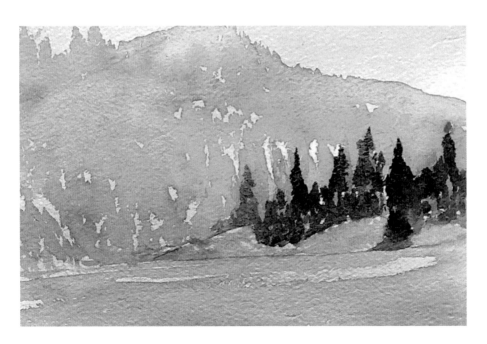

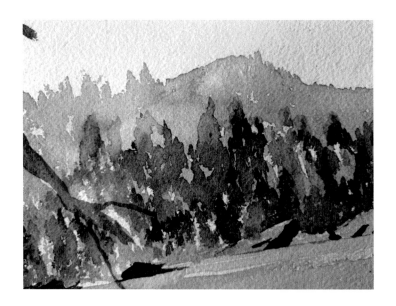

Now we will complete adding the details to the tree line and define the far edge of the water.

I have also painted some dark shadows under the rocks. These shadows define their edges as well as create a sense of mass in those rocks.

For the tree bark textures (picture below), use loose brushstrokes with a dry brush. I have used Payne's Grey for the darkest values on the tree trunk. I used Payne's Grey with Burnt Sienna for the branches. The same combination can be used for the dark values on the roots.

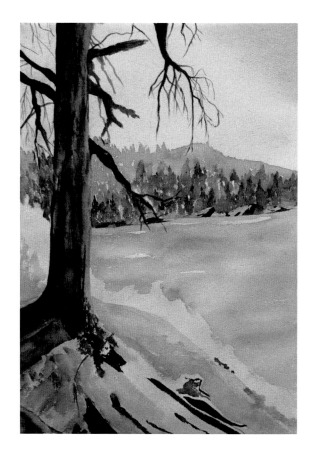

I spattered some paint (Payne's Gray, Burnt Sienna) on the land surrounding the foreground tree. It creates some excellent rough textures on the ground.

Then I put some Permanent Yellow Deep, Permanent Orange, and Burnt Sienna (separately) in a color palette. I dipped a plastic wrap in those paints randomly and dabbed the plastic wrap on the painting where I wanted the yellow-orange foliage in the foreground.

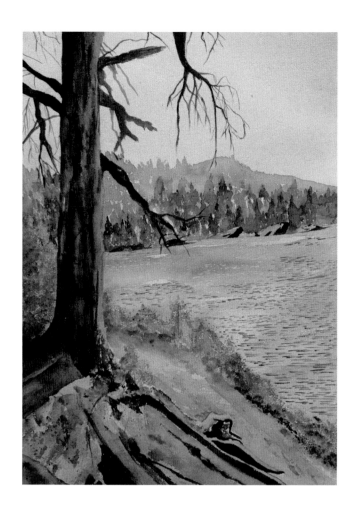

I also (very patiently) painted some ripples in the water. I have used Payne's Gray for painting the dark ripples, and a white gel pen for painting the white ripples.

When painting the ripples, make sure the pattern is not too uniform. Don't be afraid to leave some blank areas as well.

Add some sparse foliage to the foreground tree using a dry brush (Viridian and Lemon Yellow), and we are done!

You may have noticed that the foreground tree bark has a slight yellow-orange glow. It's due to the bright light bouncing off the warm-colored ground and the yellow-orange foliage surrounding the tree bark.

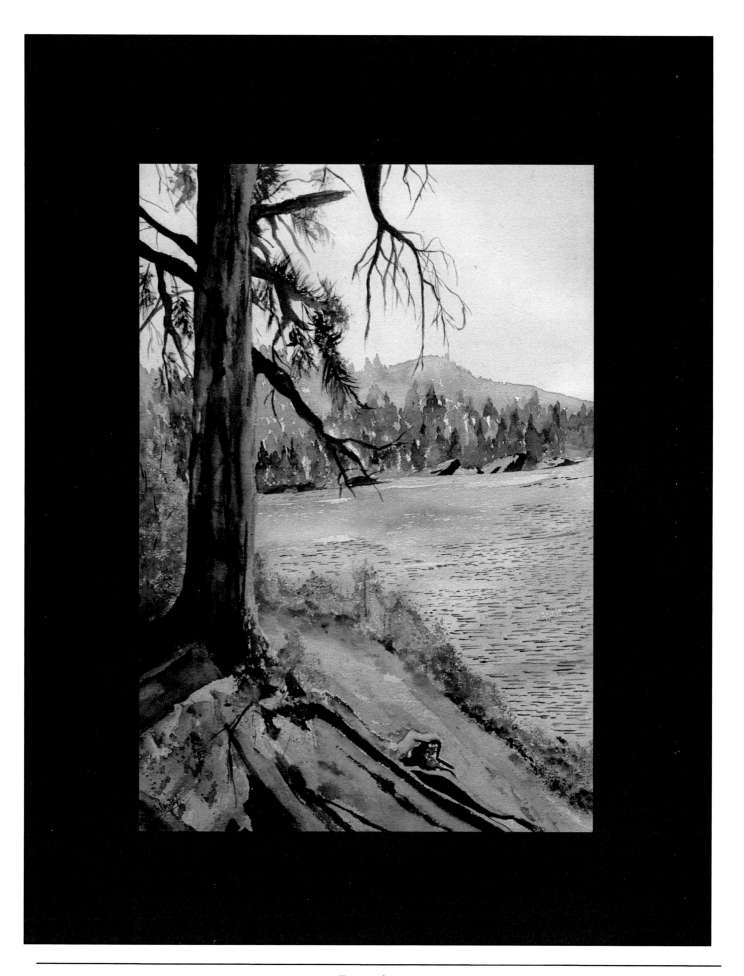

The Waterfall

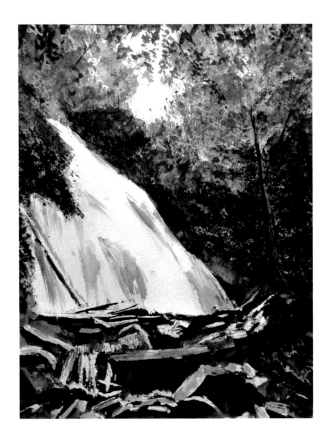

Let's paint this waterfall.

You will learn the following aspects via this painting:

- Paint pouring technique.
- Painting loosely.

You may download the rough sketch and the final illustration from this web page:

https://huesandtones.net/wcpreferences/

Bonus material: You may watch the making of this painting on YouTube by clicking the following link or scanning the QR code below (time-lapse demo at 8X speed).

https://youtu.be/0lo47SO6QUg

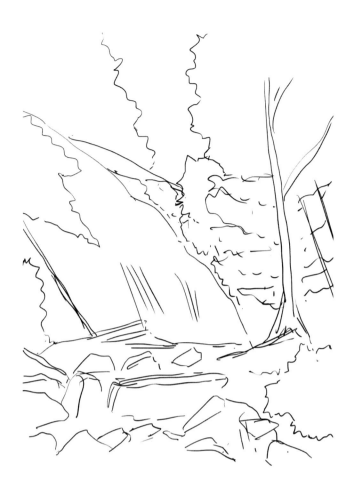

Let's begin with a simple outline of the basic shapes like this.

Note: *The outline shown here is drawn using bold strokes only for your understanding. The actual outline should be drawn with a light pencil. The pencil strokes should be so light that they are barely visible when beginning the painting. They will get mostly obscured till the painting is finished.*

We will use an interesting technique in this painting. Unlike the earlier paintings, we will apply washes by pouring the paints over the paper! Yes, you read that right!

Let's begin.

First, we will apply some masking fluid to the parts of the painting where highlights are required. There are plenty of highlights in the foreground objects like the wet, sleek rocks and the fallen branches. The waterfall itself is mostly white.

We want to preserve these whites while allowing us to paint freely and in a loose way. That's why I used masking fluid. You may do it without using the masking fluid after some practice. But for now, let's move ahead.

This is how (ugly) the painting looks after applying the masking fluid. Let the masking fluid dry completely before going to the next step.

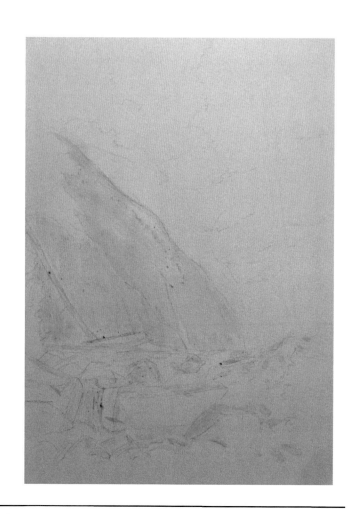

Next, I took five small plastic containers as shown below. These are repurposed containers from a food delivery I had ordered a few months ago. Each one is as tall as one digit of my thumb.

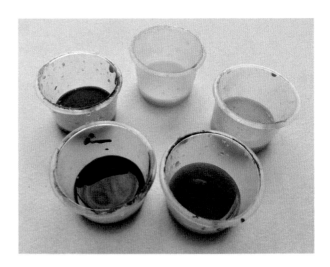

In each container, I poured some paint from the tubes.
- Prussian Blue
- Permanent Yellow Deep
- Permanent Orange
- Burnt Sienna
- Olive Green

I sprayed some water in each container to dilute the paints. Then I used a brush to thoroughly mix the paint and the water in each of the containers. I cleaned the brush after mixing the color in each container before moving to the next container. It's important that these paints remain unmixed at this stage.

Keeping the paper horizontally on a table, I poured the paints over the paper. In the upper bright parts, I poured yellows and greens. In the lower darker parts of the painting, I poured blues, browns and greens. This pouring covered nearly all the paper except the part masked with the masking fluid.

In the upper part of the painting, I kept some white spaces in the middle. This is where some background light will shine onto the waterfall.

Do not worry if you make any mistakes here. If the color accidently seeps into the supposedly white spaces, just dab it with a paper towel while it's still wet. The idea is to let go of your fears and embrace the unpredictability of the watercolor.

Let this wash dry completely before proceeding.

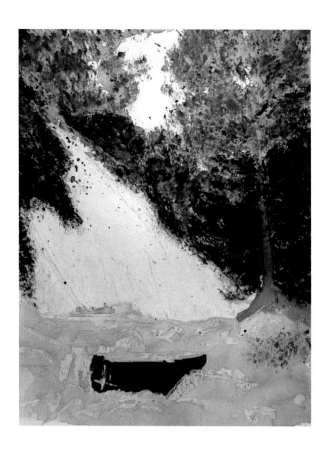

I used a plastic wrap to paint the wild foliage around the waterfall. I poured the following paints in the color palette.
- Olive Green
- Ivory Black
- Lemon Yellow

Then I lifted these colors using the plastic wrap without diluting them and applied them to the paper. Wherever I wanted dark values, I mixed black with the green. Wherever I wanted a light value, I mixed yellow with the green. I mixed these paints directly on the paper.

I also started painting the dark shadows under the rocks at the bottom of the waterfall. For these shadows, I used Raw Umber and Payne's Gray. I also threw in a little Olive Green in these shadows.

Using Olive Green, Payne's Gray and Raw Umber, I painted the shadows of the rocks and fallen branches below the waterfall. For the upper parts of these objects, I used diluted Payne's Gray to lend some bluish hues to them.

Also note the one prominent tree raising out from the right-hand side of the painting. This tree creates a nice foreground for the waterfall. Make sure you don't cover the trunk of this tree completely while dabbing the paint.

After removing the masking fluid, it's time to tidy up the edges and highlights.

I painted some leaves and small branches at the top of the painting using Olive Green and Payne's Gray (dark values).

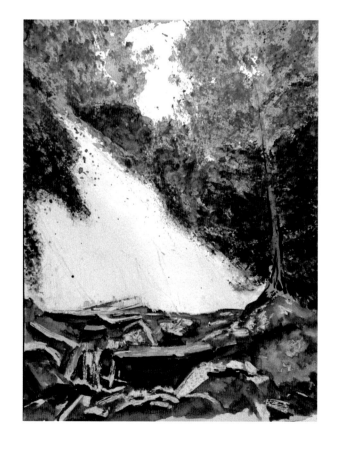

Observe how the values of the leaves attached to these hanging branches become lighter as we come down. This creates an illusion of bright light on the other side of these leaves. The leaves are translucent, and some light will filter through them, making them lighter in value.

The light on the other side of these leaves is extremely bright. So, the thin twigs holding the leaves against this light will become practically invisible because of the light seeping around them. This will make some of the leaves look like they are floating in the air. This creates a beautiful, dreamy effect.

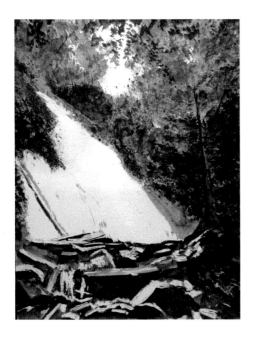 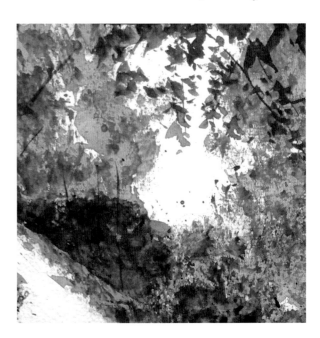

If you want, you may further darken the values of the shadows below the rocks and fallen branches. Add some light warm colors to the upper side of the rocks using yellow and brown tints.

For the shadows within the waterfall, I used Payne's Gray and painted some streaks by dragging a dry brush over the waterfall.

When masking fluid is used in a painting, it can produce hard edges for the masked areas. After the masking fluid is removed, it may be necessary to 'soften' these edges.

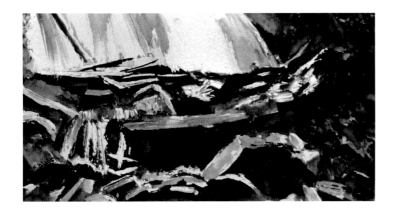

We do this by painting inside the area previously covered with the masking fluid but keeping near to the edges.

You can see this 'softening' of the hard edges over these rocks. See how some paint is subtly applied over the highlights in the picture on the left-hand side.

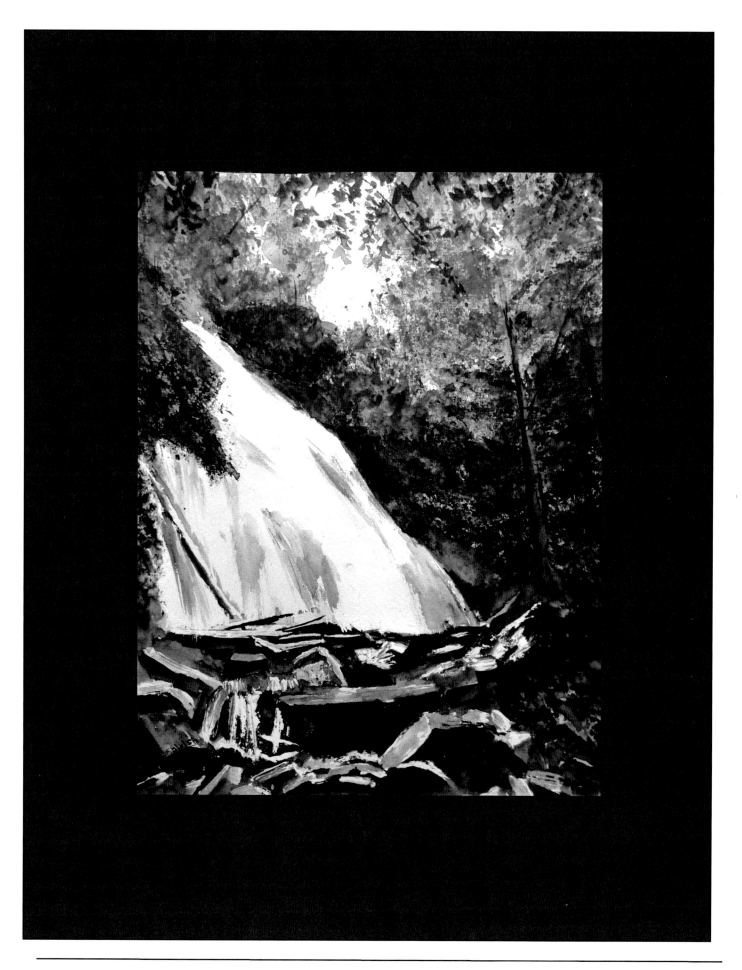

COMBINING WATERCOLOR WITH OTHER MEDIA

Pen and Ink

Pen and ink can be combined with watercolor to create some excellent effects.

Pens are ideal tools to add unique textures using techniques such as hatching, cross-hatching, stippling etc. Pen and ink can be used to create high contrast levels in a painting.

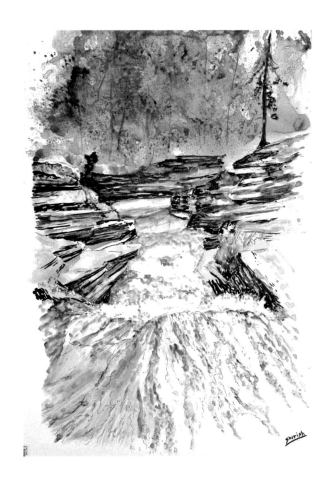

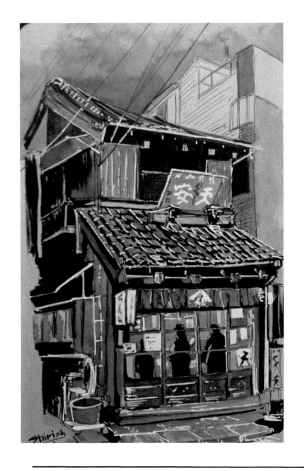

I have written several books and published several video training courses on the topic of using pen and ink along with watercolor (You can find more about my other books and courses in the 'About the Author' section). So, I will not dive deep into this subject here. But you can get a fair idea of the power of this medium from the examples on this page and the next.

Some more examples of the magic of toned paper below:

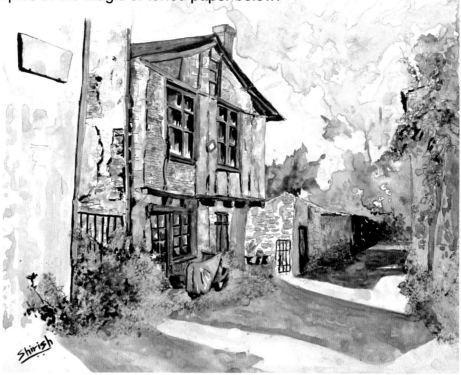

Using toned papers

While learning about values, we saw that our darkest darks and lightest light values are decided in relation to the mid-tone value.

Using a colored (toned) paper frees us from the task of deciding this mid-tone. We can simply use the paper color as the mid-tone.

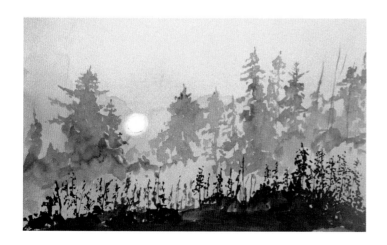

The painting on the left is done on yellow toned paper. The paper has done half the coloring for us here! I just needed to add three values to create this painting. The darkest dark is the foreground foliage. The lightest light is the white orb (the sun). Then there's one more value in-between (but darker than the color of the paper) which is used for the background tree line.

BONUS VIDEO MATERIAL

I have made time-lapse videos of the painting process for several of the watercolor paintings used in this book. All these videos are available free on YouTube.

You may subscribe to my following YouTube channel...
https://www.youtube.com/c/huesandtones

...to get instant notifications for my videos as they get published (typically once a week).

Click on the URL next to each painting (or scan the respective QR code) to watch the videos.

Waterfall in the Jungle

The Pink Arch in Morocco

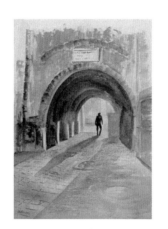

A Rainy Night Street Scene in Shibuya, Japan

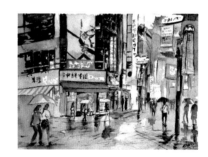

https://youtu.be/FY0WFnJZ1hQ

https://youtu.be/fQziAYR5uS0

https://youtu.be/6txUzb2t4TU

A Wet Street

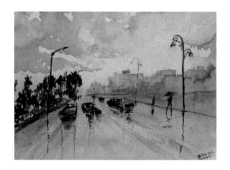

https://youtu.be/G5PHA5YRhY4

Boat at Sunset

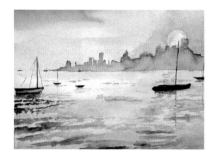

https://youtu.be/dDLZPNBj-L4

The Evening Walk Home
After a Long Day at Work

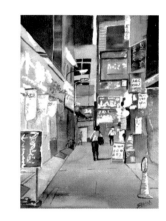

https://youtu.be/SgE--7m_rZY

A Wet Country Road

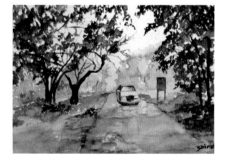

https://youtu.be/Ujxuip0XG4Y

Fog and Twilight

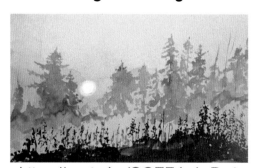

https://youtu.be/OOEFdzdwPa4

Painting with Watercolor

A Waterfront Town in Croatia

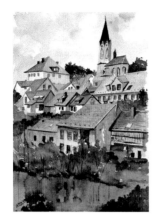

https://youtu.be/T-f7yN1gmnA

City lights and a Rainy Evening

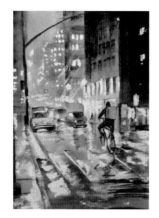

https://youtu.be/gX3M342imDo

Bubbly Stream in the Woods

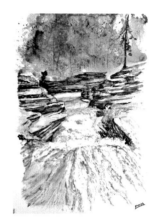

https://youtu.be/18sACi5ZP5Y

BEFORE WE PART...

I have made every effort to make this book as easy and entertaining to read as possible. I have also tried to make the medium of watercolor more 'friendly' for you.

My goal is not to show off my skills as a watercolorist, but to instill confidence in you that you can paint exceptional paintings. I hope this book has fulfilled that goal.

If you had a fear of watercolor painting, I am sure this book has dispelled it.

If you already liked watercolor painting, I hope this book instilled a new enthusiasm and a fresh perspective about the potential of this art form in you.

Finally, I will repeat the same nugget of wisdom that I have mentioned so many times before.

Do not be afraid to experiment.

Happy painting :-)

Oh… and I would appreciate it very much if you visit my website & art blog, YouTube channel, social media and my online art training courses.

You can find information about all of these on my website:
https://www.HuesAndTones.net

Or keep reading to learn more. All the links are given in the next section.

ABOUT THE AUTHOR

I am a self-taught artist based in a very populous city called Pune, in a very populous country called India.

I have worked in the thriving IT Industry for more than two decades. But I am an artist at heart. Drawing, painting and teaching art is my first, second and third love (not necessarily in that sequence!).

I dabble in various subjects such as landscapes, portraits, figure studies, and abstracts. I work in various media like pen & ink, watercolor, oil, acrylic, digital and spray paint.

I have participated in many art exhibitions. My illustrations and paintings are present in private collections in India and various other countries.

I have published some very successful video courses on various online platforms, which I produce myself. These courses have been viewed by thousands of students worldwide.

I am the author of various bestselling art instruction books.

You can see the complete list of all my books here:

https://www.huesandtones.net/books/

Video Courses:

https://www.huesandtones.net/courses/

Email: shirish@huesandtones.net

Website:

https://HuesAndTones.net

Youtube:

https://www.youtube.com/c/huesandtones

Sign up for my newsletter and get the printable PDF version of my adult coloring book 'Dystopian Encounters – Wave 1' *absolutely free*!

You will also get a handy PDF guide to the Materials for Pen and Ink Drawing + a 'cheat sheet' of pen sketching techniques.

In addition, you will get my exclusive drawing and painting tips, discount codes and information about the latest releases directly delivered to your mailbox.

You may sign up for the newsletter from the website or via this URL:

https://www.huesandtones.net/signup/

(I hate spam as much as you do, and I will neither spam your mailbox nor share your email ID with anyone else).

Facebook Page:
https://Facebook.com/HuesAndTones1

Instagram: HuesAndTones1
https://www.instagram.com/huesandtones1/

Pinterest:
https://in.pinterest.com/sd2313/

GRATITUDE

I am extremely grateful to my wife Aparna. She has consistently stood with me, encouraged me and tolerated me through all my artistic endeavors and eccentricities.

I thank many fellow art enthusiasts whose photographs I have used for various painting demonstrations in this book:

- Suhas Ekbote – An old wall covered with creeper plants
- Paul White – A serene sunset, The twin trees
- Cora Kiceniuk – A waterfront house
- Michelle Jennings – Grass and the fence
- Eman Marrei – A still life painting
- Mahesh Kale - A rustic house
- Linda Stauffer – Cabin in the snow
- Cindy Crooks – Autumn tree near a lake
- Shanna Dawn - The waterfall

I thank Cassandra Arnold for helping me with getting the book text in order and for her encouraging words. I got the perfect readers' perspective because of you!

I thank many of my readers who agreed to be my advance readers and who have made valuable suggestions which helped making this book a much better version from the initial draft.

I thank my editor Michael Pilgrim (helpingauthorssucceed.com) for patiently helping in making this book publish-ready.

And last but not the least, I thank the many fellow artists, authors, and creatives, who keep inspiring me every day. You guys are awesome!

ENJOYED 'PAINTING WITH WATERCOLOR'?

D id you receive any value from this book? Did you enjoy reading it?

If yes, would you please leave a review at the store you bought the book from?

Your review will help the book reach more readers worldwide and help them learn to sketch like a boss.

After all, the joy multiplies when shared, right? :-)

Made in the USA
Monee, IL
24 June 2023

b7626c4e-1e9b-4679-b52f-7c29c23aa3b0R01